IMAGES
of America

BRANCH COUNTY

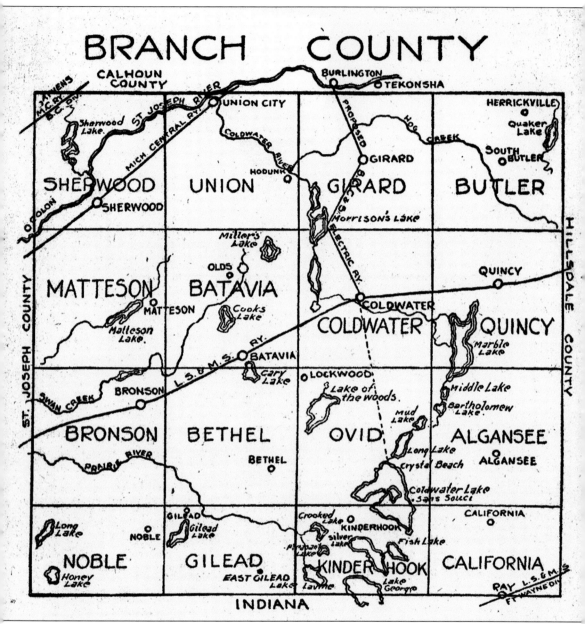

BRANCH COUNTY MAP, C. 1900. This map shows Branch County's 16 townships. The four chapters in this book consist of four townships apiece.

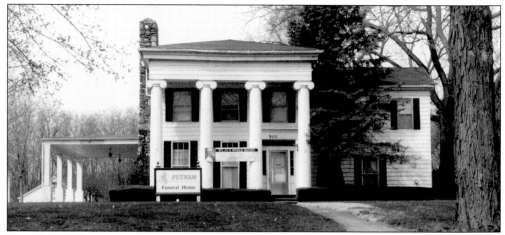

THE HURD HOME, UNION CITY, 1851. This proud Greek Revival home is a landmark in Union City. It was built in 1851 for Dr. Henry S. Hurd and his bride, Ellen (Hammond) Hurd, who was the first teacher at the Little Red Schoolhouse. Ellen Street is named in her honor, and Hammond Street is named after her family. This house became a funeral home in 1934, when it was purchased by Ernest and Eleanor Jenkins. Today it is known as the Putnam Funeral Home.

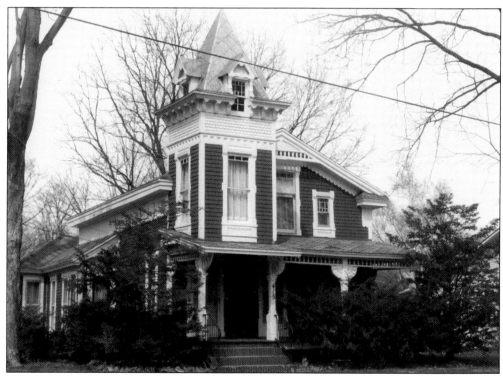

THE SUB-TREASURY, UNION CITY. This structure, originally located on the northeast corner of Broadway and High Streets, was built as a store about 1836. The store had a large room on the second floor for meetings and for school and church functions. The scarcity of money in the 1830s caused a revival of the barter system, and this building became known as the Sub-Treasury because a large iron safe was kept inside. The building was moved north on Broadway and remodeled into the home pictured here.

THE VICTORIAN VILLA INN, UNION CITY.
Built in 1876 for Dr. William P. Hurd, this brick Italianate villa has been restored and operates as a bed-and-breakfast. Owner Ron Gibson purchased the home years ago and has transformed it to its former splendor.

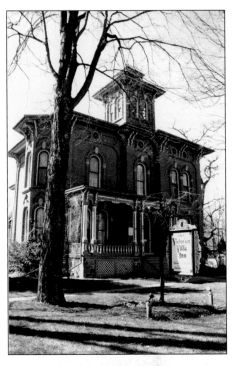

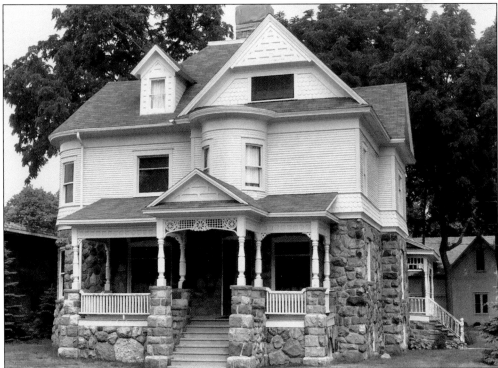

THE BUELL MANSION, UNION CITY. This Queen Anne home, completed in 1902 for D. D. Buell, survives today. The fieldstone used in its construction came from the Buell farm. The attic was finished off as a ballroom.

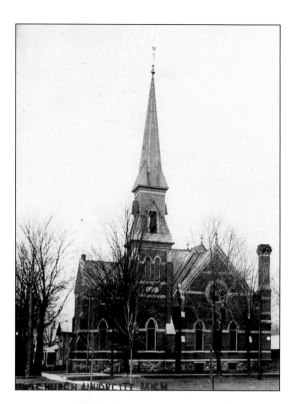

THE UNION CITY METHODIST CHURCH. Constructed in 1881, this Victorian Gothic church was built by Girard resident John R. Simmons. A basement was dug out in 1912. In 1919, the cracked bell was replaced with a new one.

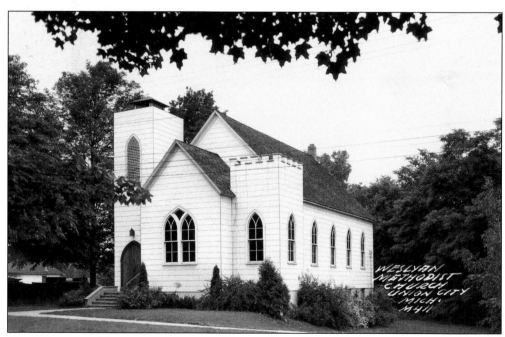

THE WESLEYAN METHODIST CHURCH, UNION CITY. This church was built in 1942 by the Wesleyans, who had left the Methodist Church in the 1850s because of their strong beliefs against slavery. This postcard was postmarked in 1960. The church's exterior is unchanged today.

THE FLOUR MILL, UNION CITY. The Union City Milling Company was established in 1839. Isaac N. Diamond and Israel W. Clark built this large mill. It had several different owners, and the equipment was modernized many times. In 1911, the Randall brothers owned the mill, using it to produce their "Spotlight" flour. The mill burned to the ground in 1948 and was never replaced.

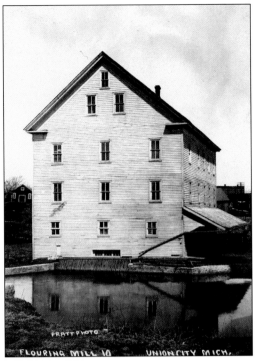

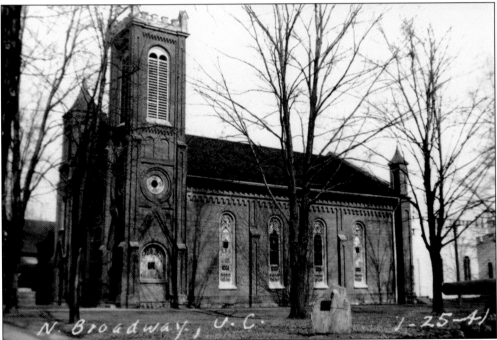

THE FIRST CONGREGATIONAL CHURCH, UNION CITY. This magnificent church was built in 1862 at a cost of $14,000. The bell, still in use today, was a gift from Col. Thomas A. Moseley in 1865. The first time the bell rang was for his funeral service. In 1917, a vast remodeling project was undertaken, which included the construction of new pews and the addition of a larger organ. This brick church is the oldest structure in the village that is still in public use.

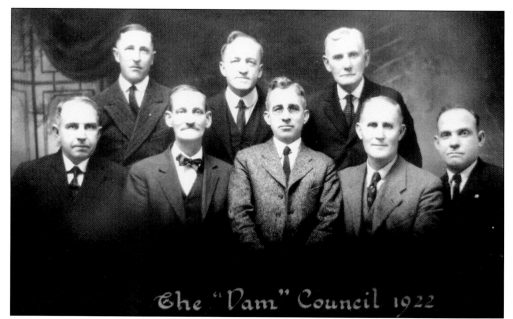

THE DAM COUNCIL, UNION CITY, 1922. Pictured are, from left to right, the following: (first row) Charles Bater, W. L. Robinson, John L. Moore, Isaac Margeson, and Samuel Bater; (second row) Howard Engle, Willard L. Brown, and J. H. O'Dell. The Union City Dam is located on Union Lake in Sherwood Township.

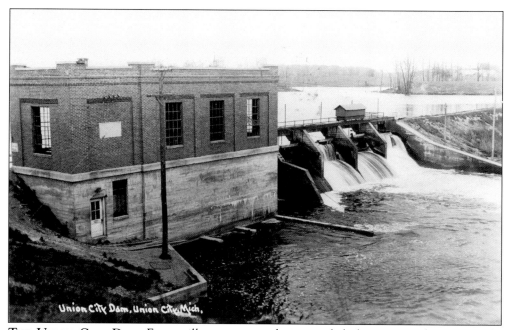

THE UNION CITY DAM. Every village, town, and city needed electricity and a waterworks system. Union City voted to build a dam, a powerhouse, waterworks, electric dynamos, wire circuits, poles, and circuit lines for the purpose of generating and transmitting electrical current. The cost of construction in 1921 was $150,000.

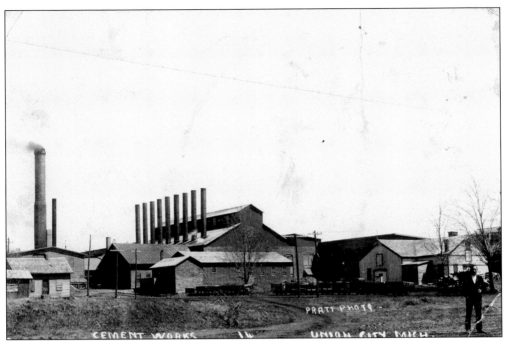

THE PEERLESS PORTLAND CEMENT COMPANY, UNION CITY. Established in 1896, this plant operated seven days a week and employed 100 men, making it the largest and most important early industry in Union City. Portland cement was manufactured by dredging the bottom of lakes for marl. Clay was then added to the marl, and the mixture was dried to a powder. The customer needed only to add water to the mixture. This plant closed in 1927.

A UNION CITY COLLECTIBLE. The weekly newspaper in Union City, the *Union City Register*, gave away these pocket mirrors with new subscriptions.

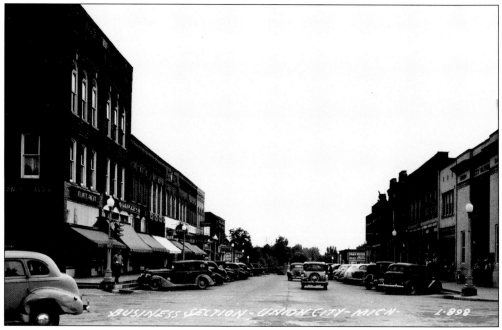

THE BUSINESS DISTRICT, UNION CITY. This photograph shows Union City's downtown in the late 1930s. On the left, the A&P grocery store occupies the first floor of the Mason Block. Next door is Dancer's Variety Store.

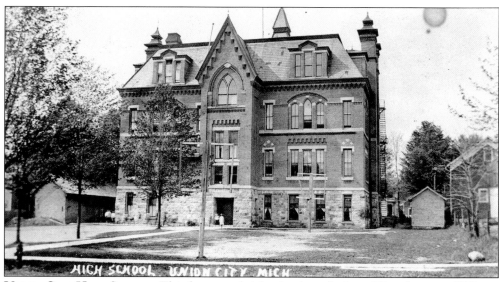

UNION CITY HIGH SCHOOL. This four-story brick school was built on Ellen Street in 1877 at a cost of $25,000. A modification removed the top floor in 1931. The school was later demolished and replaced.

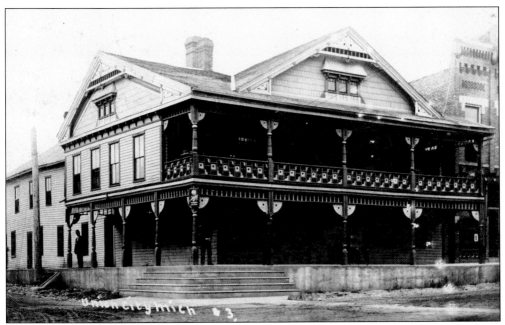

THE UNION HOUSE HOTEL. This wooden hotel was demolished in the 1930s, and the Merchant's Hardware building was built on the site in 1949. This photograph was taken around 1906.

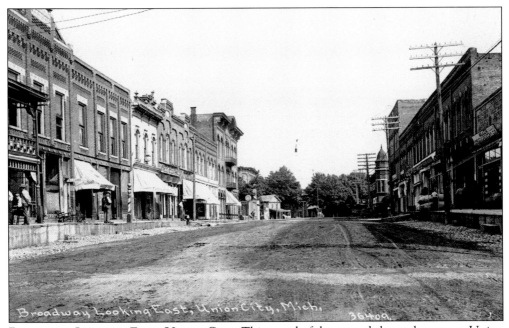

BROADWAY, LOOKING EAST, UNION CITY. This wonderful postcard shows downtown Union City when these brick stores were fairly new. The downtown area remains basically the same 100 years later.

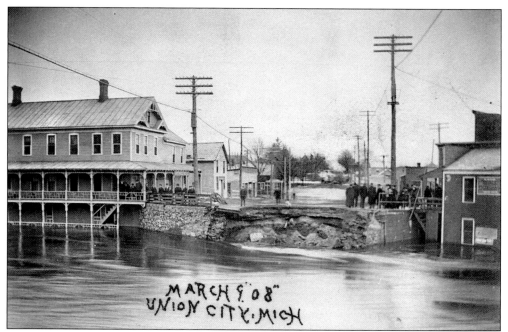

THE BROADWAY BRIDGE, UNION CITY. The water level rose and washed out the Broadway Bridge on March 9, 1908. The Riverside Hotel can be seen on the left with its two-story balconies overlooking the St. Joseph River.

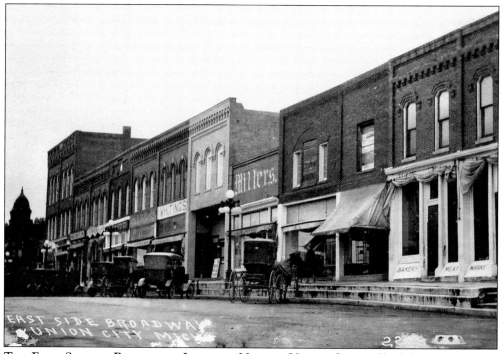

THE EAST SIDE OF BROADWAY, LOOKING NORTH, UNION CITY. All of these downtown, brick stores, which were built from the 1870s to the 1890s, survive today. This postcard is from about 1910.

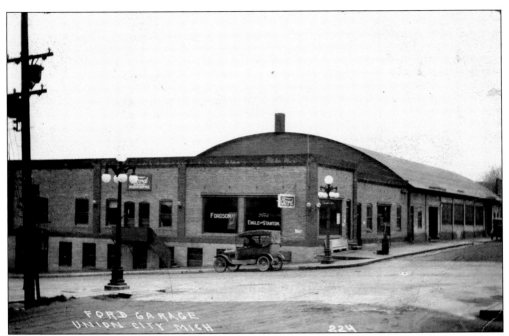

THE FORD DEALERSHIP, UNION CITY. Engle and Stanton owned the Ford dealership and garage on the southwest corner of Broadway and West High Street in Union City. The building was town down, and the city park is at this location today.

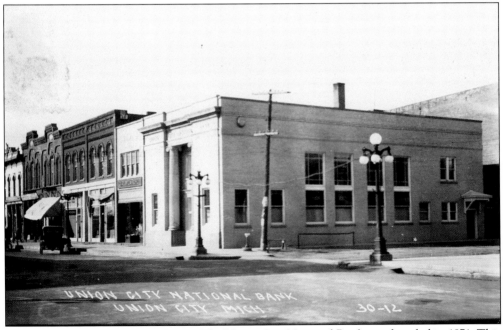

THE UNION CITY NATIONAL BANK. The Union City National Bank was founded in 1871. This corner bank building, which opened in 1922, is a little newer than the rest of the neighborhood. The old bank building, known as the Corbin Block, was razed. This photograph was taken around 1925.

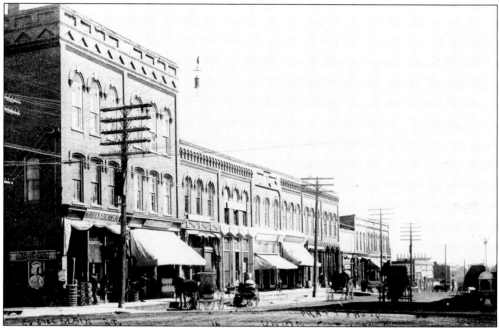

THE MASON BLOCK, UNION CITY. Looking south, the first three-story building is the Mason Block, built in 1870. The third story was for the Mason organization; the first two floors were used for retail space. Here Murdock and Dickinson Hardware occupies the first floor.

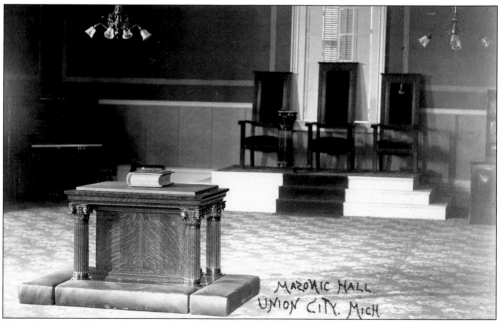

THE MASONIC HALL, UNION CITY. Shown here is the interior of the third story of the Mason Block building. The back of this postcard reads "W. L. Brown, Photographer."

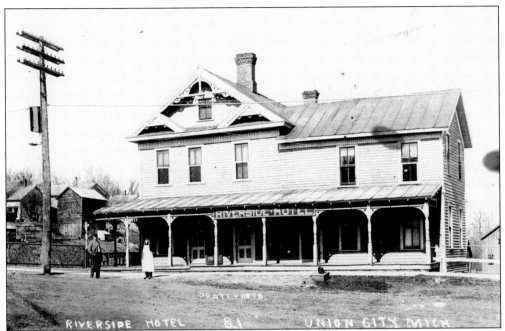

THE RIVERSIDE HOTEL, UNION CITY. Built in the early 1870s, this hotel was originally known as the Johnson House. It was later called Brown's Hotel. The building was originally located near the railway station; it was later moved next to the river. It was torn down in the late 1930s by Gerald Davison, and a trailer factory was built on the site.

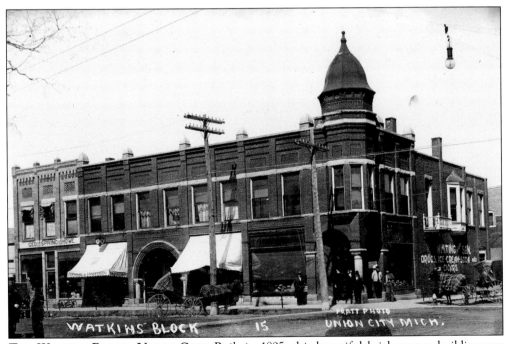

THE WATKINS BLOCK, UNION CITY. Built in 1895, this beautiful brick corner building was razed in 2003. The store on the corner is the Whiting and Son Drug Store, advertising "Drugs, Ice Cream, Soda and Cigars."

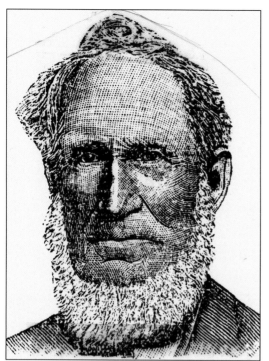

COL. THOMAS A. MOSELEY, UNION CITY. Tom Moseley (1794–1865) arrived in Union City in 1841 from Pittsfield, Massachusetts. He owned several businesses in Union City, including a flour mill, a sawmill, and the Union City Iron Company. He also had a large farm and several village lots. The home he built in 1861 on Calhoun Street, known as the Plantation, was once used as a stagecoach stop. In 1946, Emile Radebaugh purchased the home. It is now owned by children's author and illustrator Patricia Polacco.

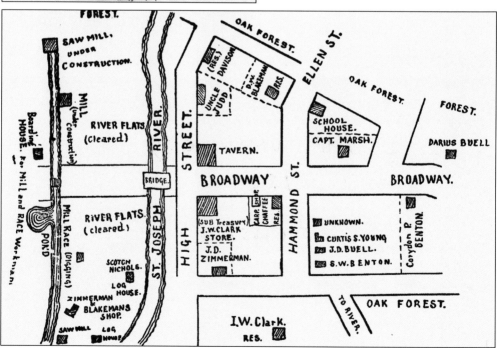

A MAP OF GOODWINSVILLE, UNION TOWNSHIP. This map shows Goodwinsville in 1839. The first permanent settler in Union City was Justus Goodwin, who bought 568 acres from J. Marvin in 1833 and named his settlement Goodwinsville. By 1840, the name Union City started to catch on, inspired by the union of the Coldwater River and the St. Joseph River. Union City was incorporated as a village in 1866 and held a large centennial celebration in 1966.

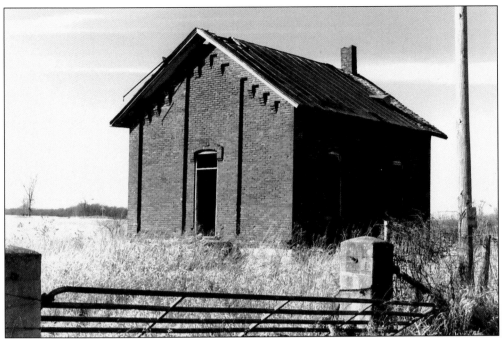

THE DISTRICT NO. 14 SCHOOLHOUSE, UNION TOWNSHIP. The Barnhart School, located on Barnhart Road, was built in 1886 and was shared by Union and Batavia Townships. It closed in 1956; the last teacher was Marie Shaw. This 2004 photograph shows how time has ravaged the school. Across the road, the Barnhart Church is used for farm storage.

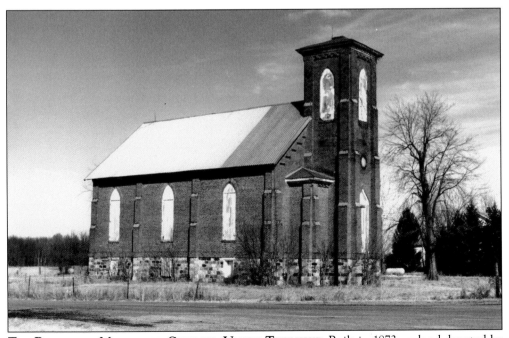

THE BARNHART METHODIST CHURCH, UNION TOWNSHIP. Built in 1873 on land donated by the Barnhart family, this church still stands at the intersection of Adolph and Barnhart Roads. It is now used for storage.

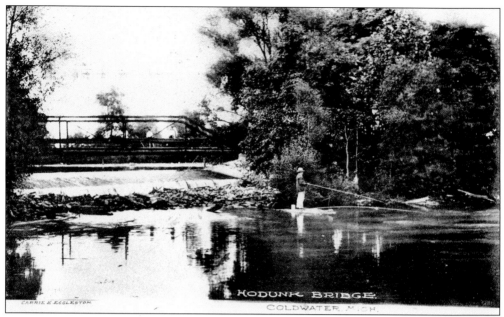

THE HODUNK BRIDGE, UNION TOWNSHIP. This postcard, which bears a postal cancellation from 1908, shows a fisherman at the Hodunk Bridge. Hodunk was previously called Orangeville, presumably after the large number of Osage orange hedges, which were planted as fences.

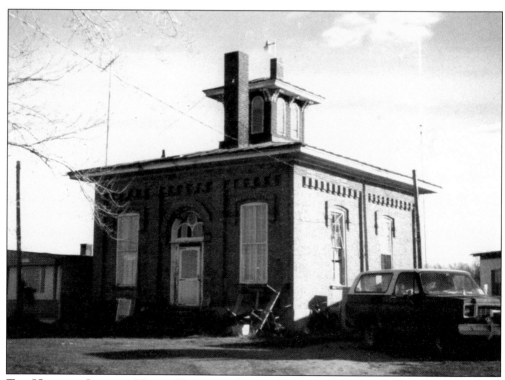

THE HODUNK SCHOOL, UNION TOWNSHIP. Located on Union City Road, this school was used for storage after its closing. It was demolished in the 1990s.

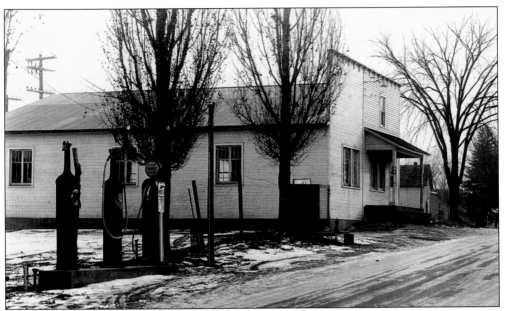

THE HODUNK TAVERN, UNION TOWNSHIP. The Olds family owned this business from the 1930s to the mid-1940s. In the mid-1970s, this building suffered fire damage. A health institute is now located on this site.

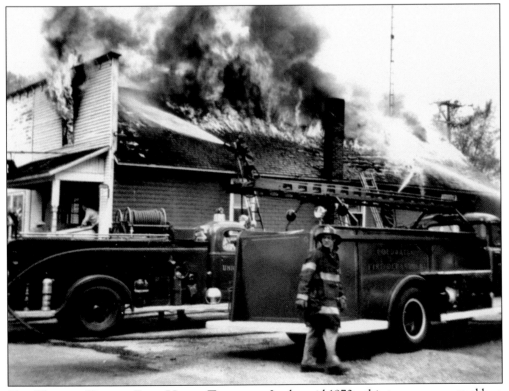

THE HODUNK TAVERN FIRE, UNION TOWNSHIP. In the mid-1970s, this tavern was gutted by a devastating fire.

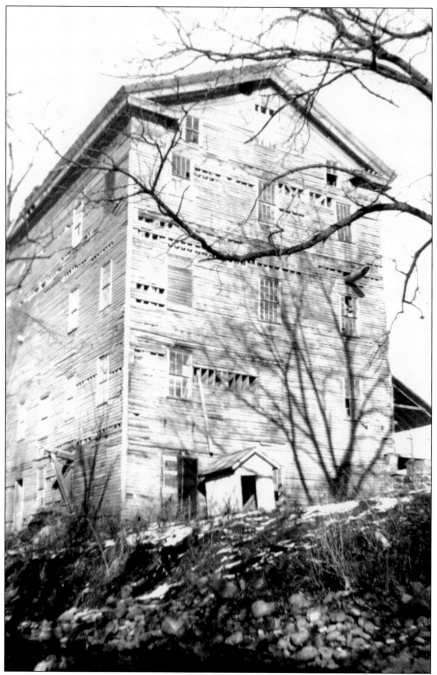

THE HODUNK MILL, UNION TOWNSHIP. Roland Root built this five-story mill in 1847. This site had previously been home to a mill built by Abram Aldrich, a Quaker from Wayne County, New York. The junction of the Coldwater River and Hog Creek made an excellent site for a settlement. Roland Root's mill still stands today, restored by Don Haughey, who owns a health institute in Hodunk. Hodunk, previously called Orangeville, had a post office by 1887. Legend has it that the town's name came from an old settler who came to town on a donkey. To get the animal to stop, he would yell "Whoa, Donk!" This photograph is dated December 24, 1939.

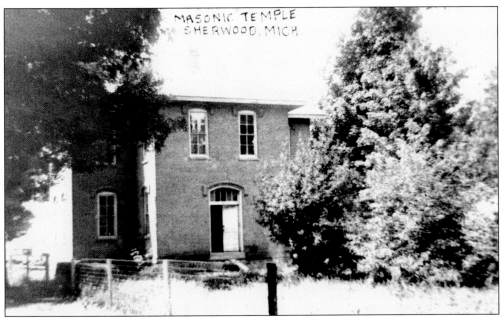

THE MASONIC TEMPLE, SHERWOOD. Built in 1892, this building first served as an elementary and high school. In 1895, the school moved into the larger old college building and sold this building to the Masonic organization. Sherwood was given its name by its first settler, Alexander Tomlinson, who came from Nottingham, England, and arrived in Branch County in 1832.

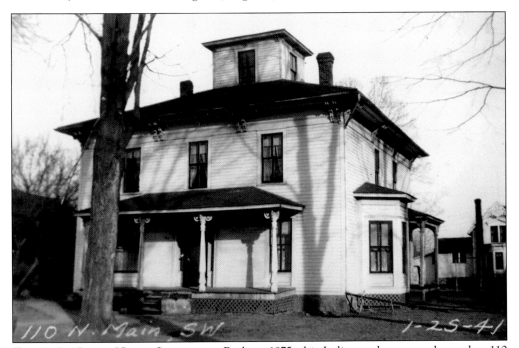

THE E. F. HAZEN HOME, SHERWOOD. Built in 1875, this Italianate home was located at 110 North Main Street. Sherwood suffered a series of devastating fires: one in 1909, another in 1915, and the fire of 1923, which destroyed half of the business district. The businesses that survived the fires suffered further in the Great Depression.

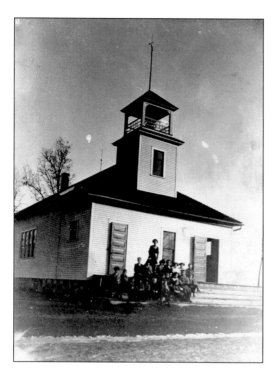

BATAVIA STATION NO. 3. This large school, located just north of Route 12 on Batavia Road, housed first through eighth grades. The teacher listed on the back of this photograph is Lena Wilmarth. Other teachers who taught at this school include Ella Lashuay, Una Crum, Blance McMachan, Ethel Taylor, Jim Burnside, Eva Shcook, Esther Libert, and Gwendolyn Langworthy.

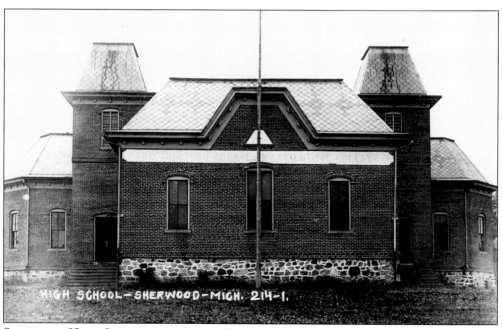

SHERWOOD HIGH SCHOOL, 1910. M. V. Rork, a Methodist minister who wanted to start a college, constructed this building in 1880. The college failed, and in 1886, F. L. Kern purchased the college and renamed it Sherwood Scientific and Normal College. It closed in 1893. The community school system then purchased the building, which featured four classrooms and held 400 students. The school closed in 1959 and was later demolished.

THE BATAVIA FIRST CONGREGATIONAL CHURCH. Built in 1890, the church is shown here in 1940. It no longer exists.

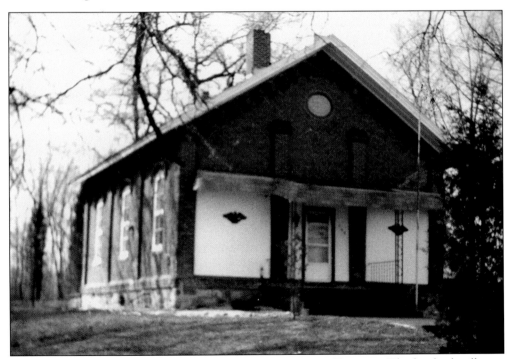

THE CENTENNIAL SCHOOL, DISTRICT NO. 2, COLDWATER AND BATAVIA. This brick schoolhouse was built in 1876—hence the name Centennial. It has been converted into a residence. The school was shared by Coldwater and Batavia because of its location on the southeast corner of Hodunk and Miller Lake Roads.

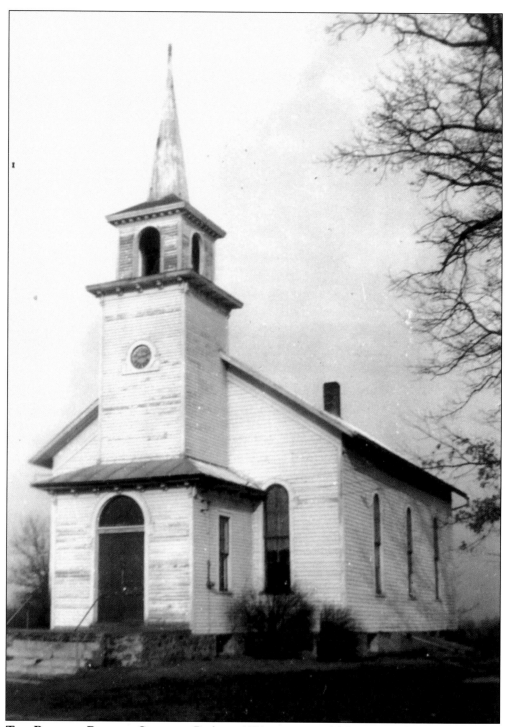

THE BATAVIA BAPTIST CHURCH. Built in 1881 at a cost of $589.88 on the land of Joseph Sheneman, this church is still in use today. A basement was dug out in 1932, a new furnace was installed in 1941, and a new organ was donated in 1958. The church is now known as the Batavia Free Will Baptist Church.

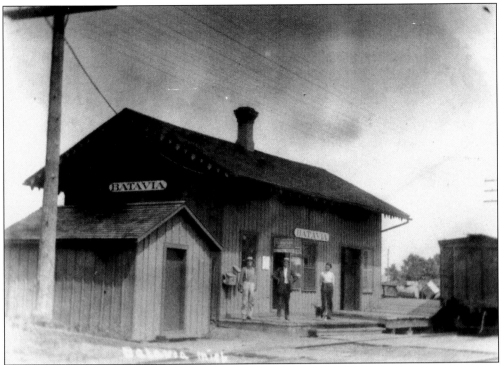

THE BATAVIA TRAIN DEPOT. This building was constructed in 1850 to serve as Coldwater's train station. After it was replaced with a new brick depot in 1883, Coldwater sold the old wooden depot to Batavia, and it was shipped down the tracks. Passenger service in Branch County ended in 1956. The wooden depot sat empty for a time, was then used for storage, and later was moved away from the tracks and forgotten. It was finally rediscovered, restored, and moved back to Coldwater in the 1990s. It is one of the oldest remaining train depots in Michigan.

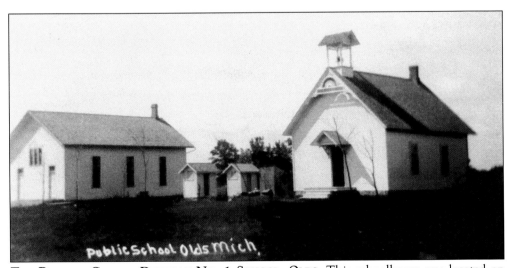

THE BATAVIA CENTER DISTRICT NO. 1 SCHOOL, OLDS. This schoolhouse was located on North Snow Prairie Road at the intersection of Route 86. The original Batavia town hall is shown on the left. Olds was a small settlement that only lasted for a few years.

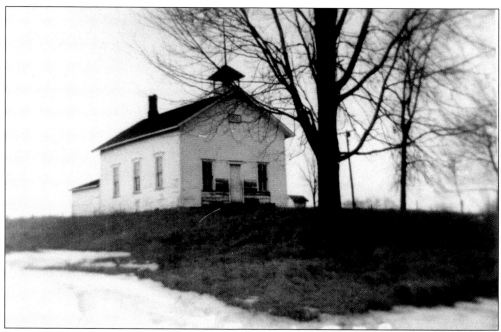

THE MATTESON DISTRICT NO. 5 SCHOOL. The Gardner School was built in 1848. It closed in 1935, and the students were bussed to Sherwood schools. This photograph is dated January 5, 1938. Matteson Township was named after its first settler, Amos Matteson, who came here from Rhode Island in 1836.

THE MATTESON DISTRICT NO. 4 SCHOOL. Lindley School was built in 1891 and had a full basement. This brick school was closed in 1965 and has been converted into a residence. It is located on the southwest corner of Lindley and Matteson Roads.

Four

THE NORTHWEST CORNER

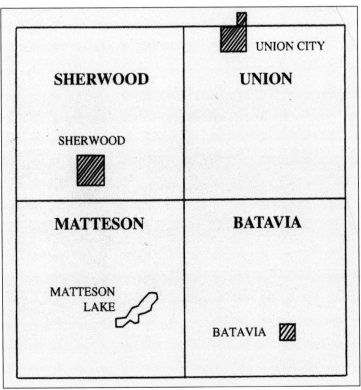

THE NORTHWEST. The northwest section of Branch County includes the four townships of Sherwood, Union, Matteson, and Batavia. The Village of Union City was established in 1866, originally named Goodwinsville after its first settler, Justice Goodwin.

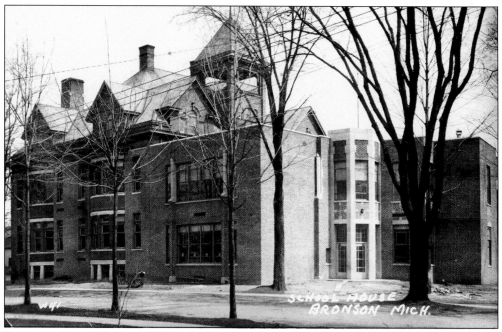

BRONSON HIGH SCHOOL. This school was built on East Chicago Street in 1901 at a cost of $3,500. It is shown here in the 1930s with an updated art deco façade. The building was eventually razed, and a new school sits on this site.

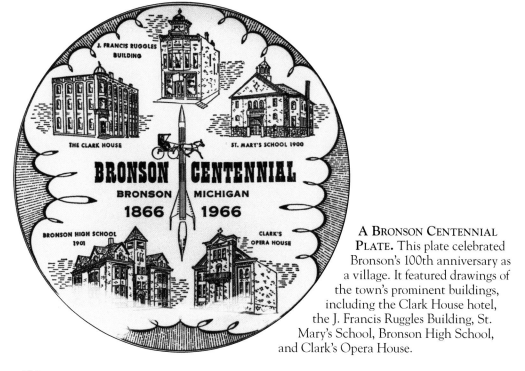

A BRONSON CENTENNIAL PLATE. This plate celebrated Bronson's 100th anniversary as a village. It featured drawings of the town's prominent buildings, including the Clark House hotel, the J. Francis Ruggles Building, St. Mary's School, Bronson High School, and Clark's Opera House.

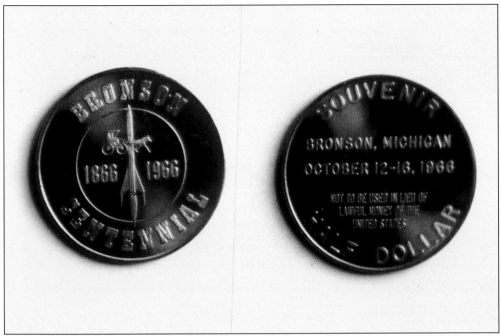

A BRONSON CENTENNIAL COIN. This brass coin was good for 50¢ during the 100th birthday celebration of Bronson, held October 12–16, 1966. The coin featured the centennial logo—a horse and buggy and a rocket ship—as well as the dates of Bronson's existence, 1866–1966.

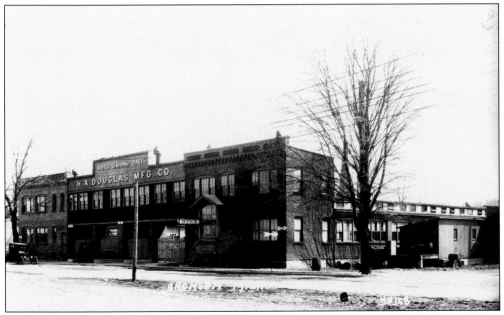

DOUGLAS MANUFACTURING, BRONSON. Douglas Manufacturing was established in 1902 as Warner and Douglas Company with 15 employees and capital of $10,000. The company grew to employ 600 people and became part of a $25 million corporation. Its products included automotive lamps, sockets, terminals, connectors, and Kingston vacuum sweepers.

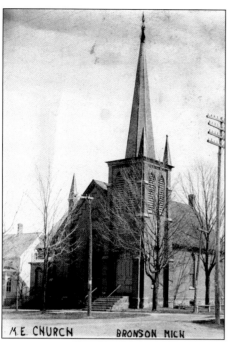

THE METHODIST CHURCH, BRONSON. This church, located on East Chicago Street, was built in 1871 and was demolished in the mid-1960s. It was replaced with a new church in 1967.

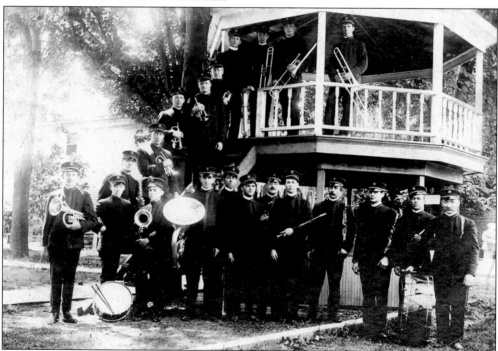

THE BRONSON MUNICIPAL BAND, 1908. The band is pictured here at the old bandstand, which was located where the present Bronson Theatre stands. Pictured are, from left to right, the following: (first row) Joe Corson, Howard Hickey, Verne Warner, Charles Auten, Alfred Billings, Glen Knickerbocker, director Fred L. Warne, Fred D. Jones, Burt Walker, Oral E. Clark, Leslie Mountz, and Jud Hickey; (second row) John N. Paulson, Earl D. Jedd, Leo Powers, William H. Davis, Laurence Werner, George F. Davis, Ray Warner, Fred Baxter, and Henry Russell.

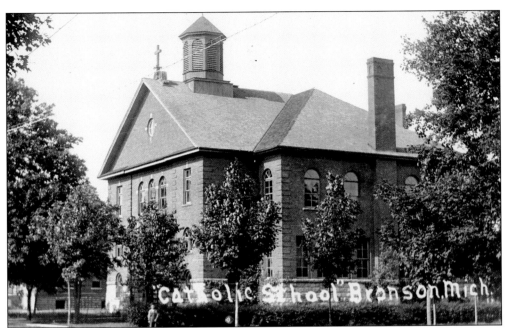

ST. MARY'S CATHOLIC SCHOOL, BRONSON. This building was located on North Matteson Street, just north of St. Mary's Catholic Church. Built in 1901, the school had four classrooms and a parish hall. It was replaced in 1956, and the building was eventually razed.

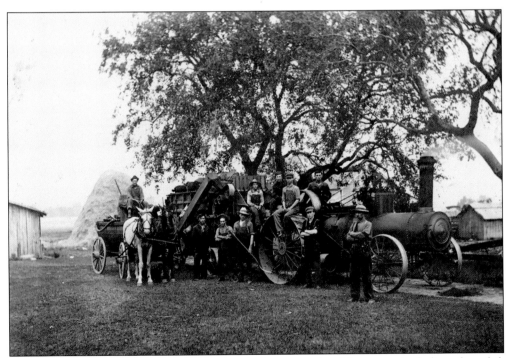

BRONSON FARMERS. This c. 1915 photograph features a threshing crew, including, from left to right, Lawrence Bystry on the water wagon, Tom Zyock, unidentified, Laddie Wotta, two unidentified men, Harold Bates, unidentified, Steve Kibiloski, and unidentified.

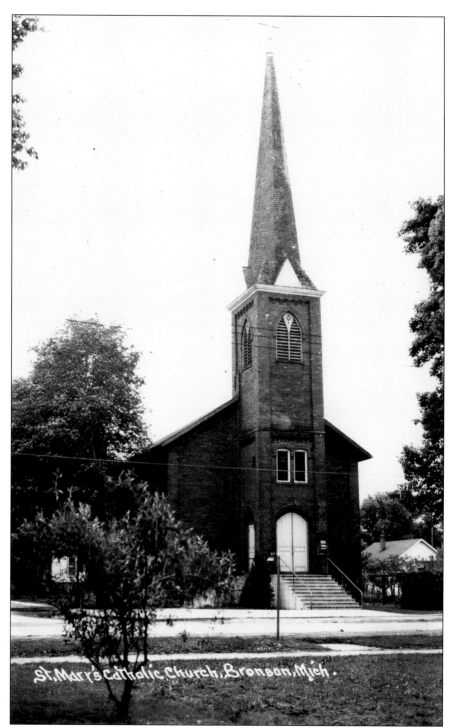

ST. MARY'S CATHOLIC CHURCH, BRONSON. This church was built in 1886 on the southeast corner of Matteson and Fillmore Streets. It had a seating capacity of 300. The building served its parishioners well until a new church and school was built on the west side of town in 1956. This old church, left to the elements, was eventually torn down.

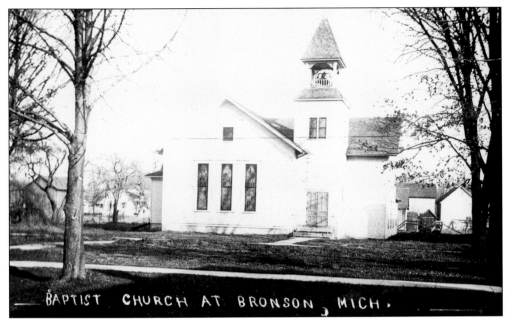

THE FIRST BAPTIST CHURCH, BRONSON. Organized in 1857, the Baptist congregation built this church in 1861. Because of the Civil War, it was not quite completed until 1864. It is located on Buchanan Street and is still in use today. A pipe organ was added in 1878, and several remodeling projects have been undertaken during the building's history.

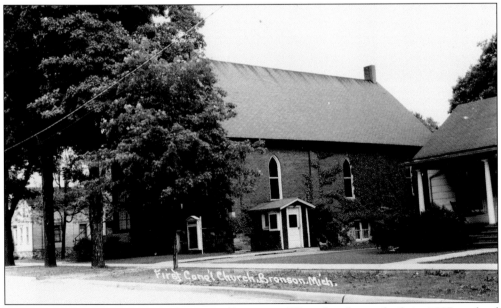

THE FIRST CONGREGATIONAL CHURCH, BRONSON. This church was built in 1887 on land donated by Anson Horton, who lived in the house next door. The church later purchased the Horton home. William Cockle helped build the church. The church was closed from 1933 to 1937 during the Depression. In the late 1930s, Dr. William P. Mowry donated a pipe organ from the Tibbits Opera House in Coldwater. The church still exists and has undergone several additions and remodeling projects.

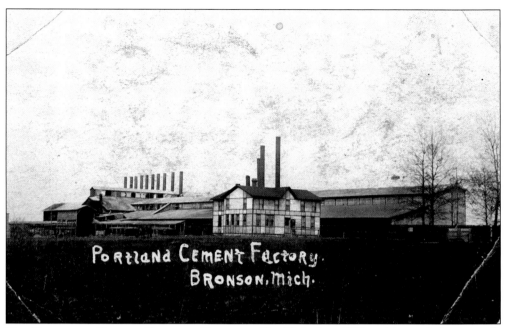

THE PORTLAND CEMENT FACTORY, BRONSON. Established in 1897 and located about a mile northeast of Bronson, this factory brought much-needed jobs to the area. As a bonus, cement sidewalks were built to replace the wooden-plank sidewalks downtown. Approximately 80 men had jobs with the cement plant. At its peak production, the factory produced 700–800 barrels of cement every 24 hours.

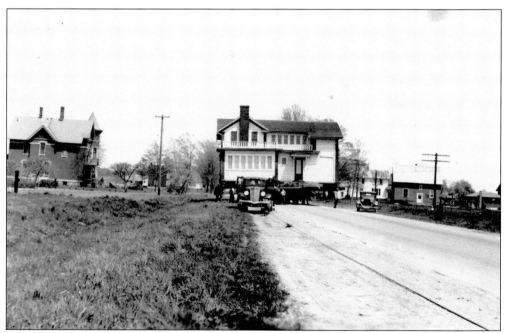

MOVING THE DOUGLAS HOME, BRONSON. The Douglas home was located near downtown Bronson. It is shown in this c. 1930s photograph moving westward down Route 12 toward Mallows Farms.

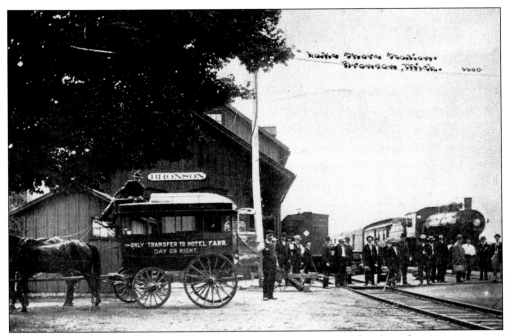

THE BRONSON TRAIN DEPOT. The trains came to Bronson in 1851. Note the taxi waiting to take passengers downtown to the Hotel Farr.

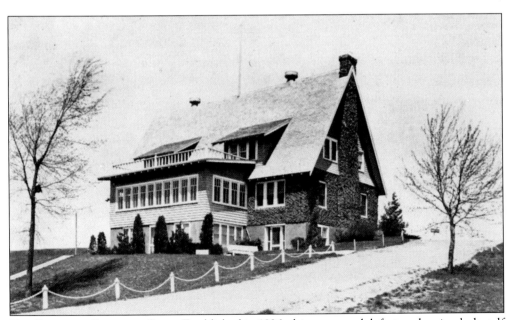

THE BRONSON COUNTRY CLUB. Established in 1926, this country club featured a nine-hole golf course. It was located on the banks of the Prairie River.

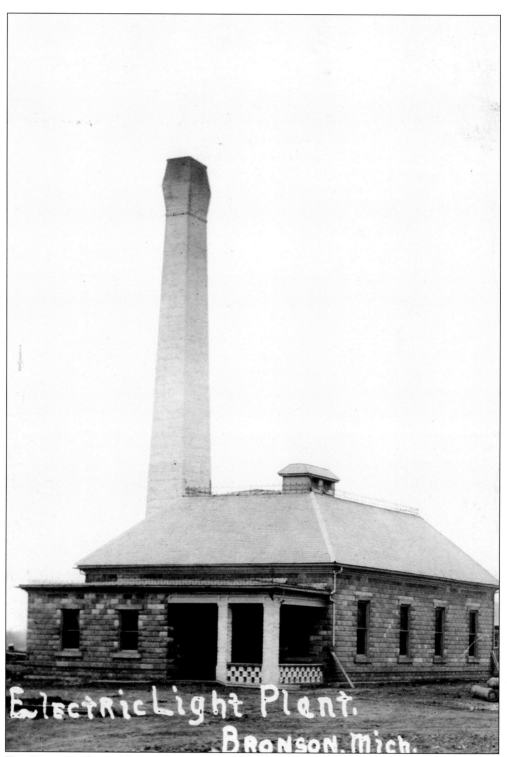

The Electric Light Plant, Bronson. Built in 1886 near the railroad, this plant also had the fire whistle attached to it to warn citizens of local fires.

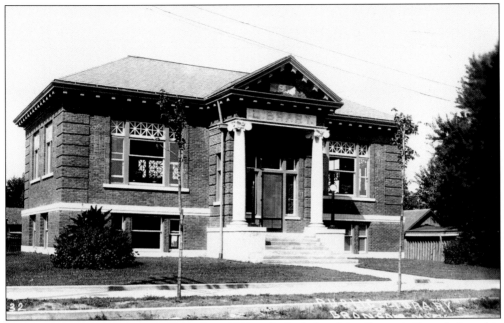

THE BRONSON PUBLIC LIBRARY. Built in 1911 with the help of the Carnegie Foundation, this wonderful library is still open and keeping up with the literary needs of Bronson. It is part of the countywide library system and has received a state historical marker.

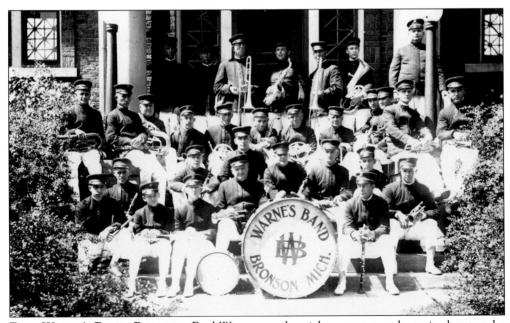

FRED WARNE'S BAND, BRONSON. Fred Warne was the night operator at the train depot and a fine cornet player. He organized this band in 1892. After five years, Warne moved away, and the band struggled to survive. Jewelry store owner William Davis directed the band until 1937.

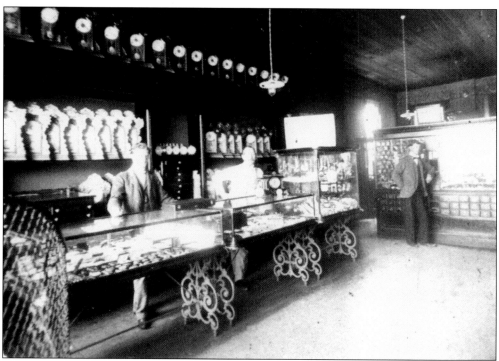

DAVIS AND JONES JEWELRY, BRONSON. J. E. Watson established a jewelry store in downtown Bronson in 1876. William Davis joined the firm in 1892, and Charles Jones joined in 1923.

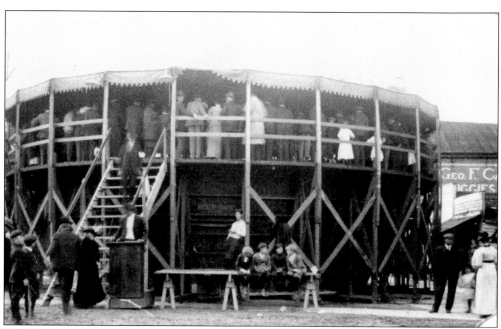

THE MOTOR DOME, BRONSON. Ernie Reynolds built this temporary structure in 1912. Admission cost 15¢ for adults and 10¢ for children to watch men drive motorcycles around a banked drum. The challenge was to see how close to the top of the drum one could drive.

THE PEOPLES STATE BANK, 1954. In 1910, the L. Rudd and Son Bank, established in 1883, was forced to close its doors and was reorganized as the Peoples State Bank. Dr. H. P. Mowry served as president. The bank operated into the late 1960s. This office is easy to spot on the south side of East Chicago Street because there is a clock attached to the façade.

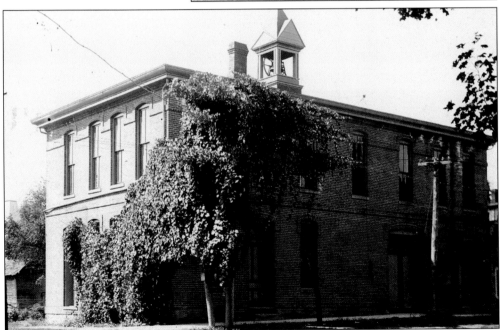

THE BRONSON TOWN HALL. Constructed in 1884 at a cost of $3,000, this two-story brick building housed the library, the jail, and two rooms for village and township meetings. The police and fire department building now sits on this site.

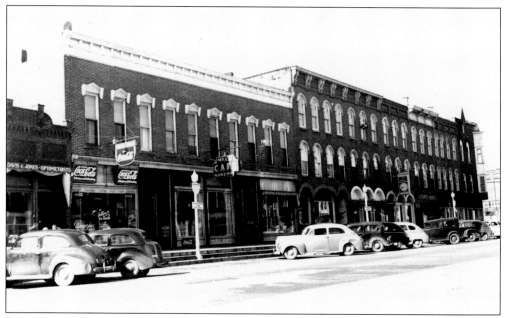

DOWNTOWN BRONSON, SOUTH SIDE. Some of the businesses shown here are, from left to right, Davis and Jones Jewelry, Mel's Café and Bakery, Peoples State Bank, and the A&P Grocery Store. All of these buildings were razed after a fire in 1970.

DOWNTOWN BRONSON, 1940. Shown is the south side of East Chicago Street in 1940. All of these brick buildings were constructed between 1867 and 1869. Bronson had its share of fires, and all of the wooden buildings downtown were replaced with brick. In 1970, a fire damaged enough of these 100-year-old buildings to result in them all being torn down.

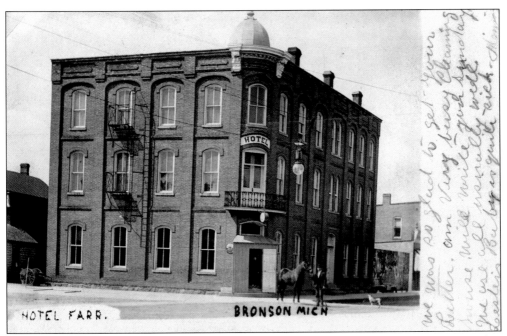

THE HOTEL FARR, BRONSON. Milo Clark built the impressive three-story brick hotel pictured in the postcard above in 1880. It had many names through the years, including the Bronson Hotel, the Fischer Hotel, and the Bronson Inn. As spending the night downtown became less popular, the building slowly fell into disrepair, and it was razed in 1973.

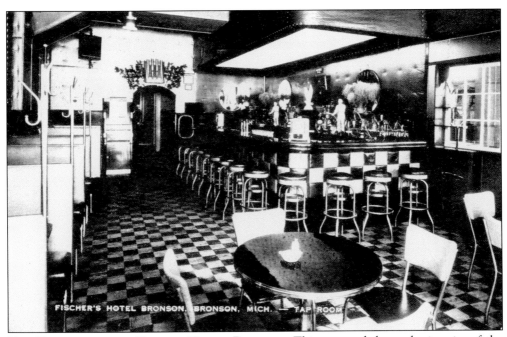

THE TAPROOM OF THE FISCHER HOTEL, BRONSON. This postcard shows the interior of the Fischer Hotel (Hotel Farr) in 1947.

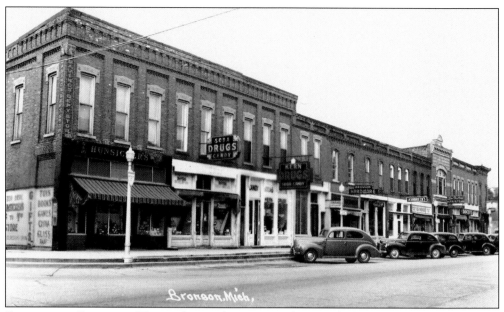

DOWNTOWN BRONSON, NORTH SIDE. This c. 1920 photograph shows the north side of East Chicago Street. The first couple of stores on the right later became the Miller Do-It Center.

THE CLARK OPERA HOUSE, BRONSON. Milo Clark built this opera house in 1884. Clark sold buggies and wagons on the first floor of the building; upstairs, people could enjoy a show at the opera house. The building is shown here in the early 1950s, when it served as a Chevrolet car dealership and gas station.

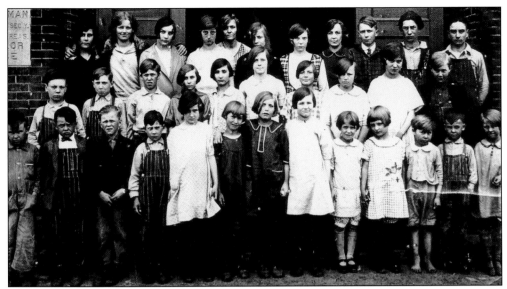

THE 1927 CLASS OF THE GILEAD DISTRICT NO. 3 SCHOOL. The 1927 students of the Luce School are, from left to right, the following: (first row) Leonard Wheeler, Charles Wheeler, Raymond Holiday, Max Cranson, Geneva Martin, Wava Burch, Blanch Nutt, LaVern Wheeler, Mable Nutt, Thelma Louise Hoopingarner, Clarence Burch, Stanley Green, and Violet Hope Rubley; (second row) Willard Pabst, Kenneth Cranson, Randall Burch, Florence Hanny, Gwendolyn Cranson, Laura Jean Oaks, Glendora Bowers, Eleanor Berk, Wilma Burch, and Leroy Nutt; (third row) Marie Bowers, Nina Nutt, Gwendolyn Hoopingarner, Alice Burch, teacher Mrs. Oaks, Alice Nutt, Rea McPeak, Norene Steffey, Robert Hubbard, Versal Burch, and Ralph Hoopingarner.

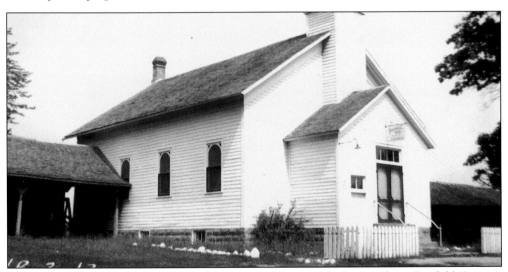

THE MENNONITE CHURCH, NOBLE TOWNSHIP. A group of pioneers from Fairfield County, Ohio, settled in Noble Township in search of new and cheaper land. They built this place of worship in 1869 on land donated by Daniel Beery. The head carpenter was Tobias Kreider, and the first pastor was Christian Beery. The church was named the Pleasant Hill Missionary Church, and it served Mennonite, Mennonite Brethren in Christ, and Brethren congregations. The original 1869 church has been enlarged and remodeled.

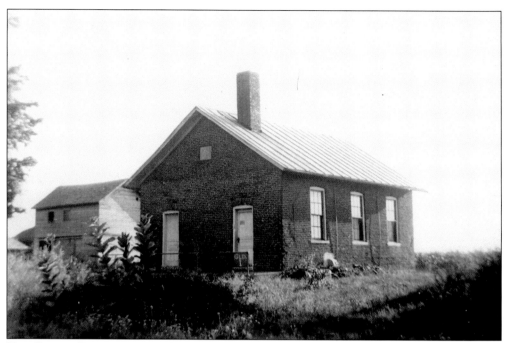

THE GILEAD DISTRICT NO. 1 SCHOOLHOUSE. Built in 1869, this school was known as Marsh's Corner. The building survives today as a farm shop.

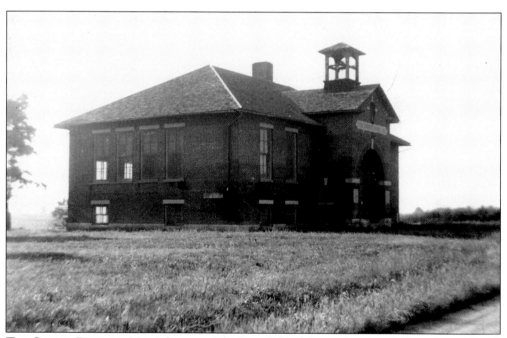

THE GILEAD DISTRICT NO. 3 SCHOOL. The Luce School, located on South Snow Prairie Road, was built in 1908 and closed in 1945. The children were then bussed to Bronson community schools. This large facility, with two classrooms and a full basement, is now used for storage.

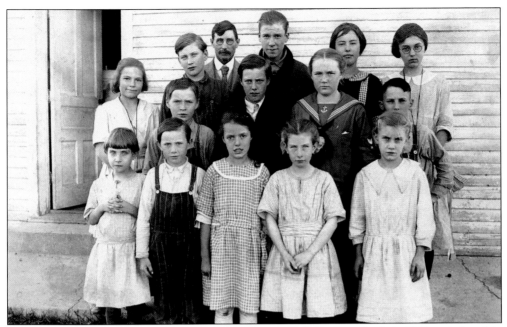

THE BETHEL DISTRICT NO. 7 SCHOOL. The "Cranson" School was built in 1868 and closed in 1944 with the children being bussed to Bronson schools. This photograph is dated December 1922 and features, from left to right, the following: (front row) Lois (Bonecutter) Bennett, Frank Honeywell Jr., Jessie (Porter) Benton, Mareta (Bonecutter) Mutzfeld, and Dorothy (Heroy) McCullough; (second row) Glen Honeywell, J. C. Porter, Mildred Honeywell, and Orville Keefler; (third row) Lucile (Hillyer) Whitcomb, Williams, Floyd Heroy, Delphis Hamilton, Alice (Porter) Byers, and Ona May (Olmstead) Mowry, Mitchell; (rear) Fred J. Mock, teacher.

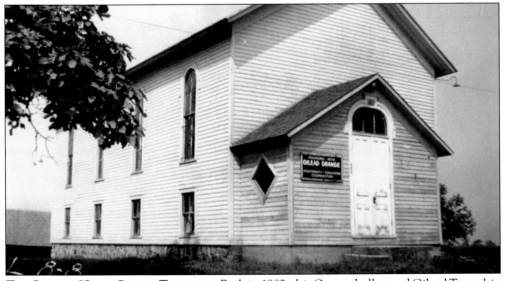

THE GRANGE HALL, GILEAD TOWNSHIP. Built in 1882, this Grange hall served Gilead Township until the organization decided to dissolve in 1978. Gilead received its name from an early settler, Bishop Philander Chase, who came here from Mount Gilead, Ohio.

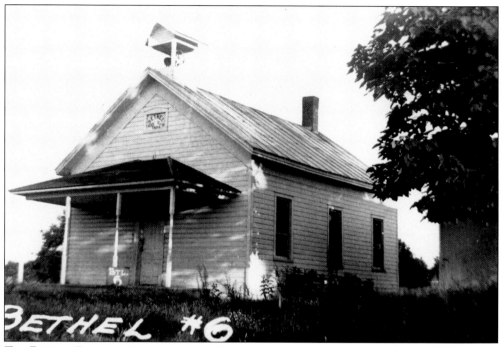

THE BETHEL DISTRICT NO. 6 SCHOOL. This school, built in 1864, was closed in 1963, and the children were bussed to Bronson schools. This wooden building was eventually torn down.

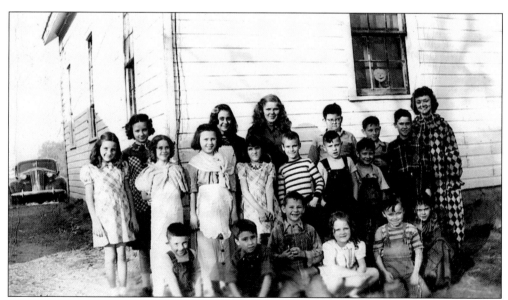

THE 1948 CLASS OF THE BETHEL DISTRICT NO. 6 SCHOOL. Shown is Delores Widener's (née Lanka) class in 1948. She went on to teach at Fox School and Centennial School. In 1991, she retired from Lakeland School after teaching for a total of 33 years, having taken 10 years off to raise a family.

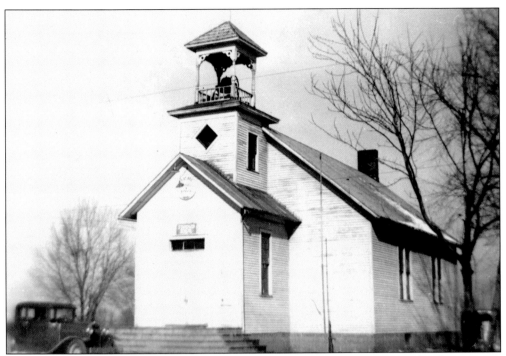

THE BETHEL DISTRICT NO. 3 SCHOOL. Butcher School was built in 1906 and still exists as a storage building. It is located on Butcher Road.

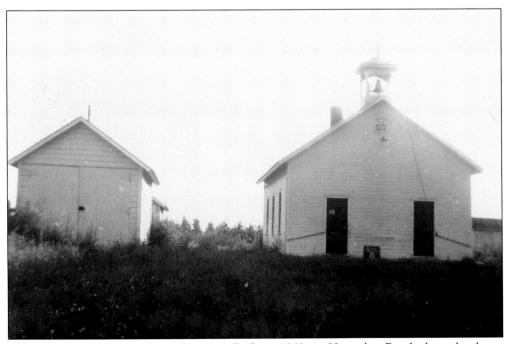

THE BETHEL DISTRICT NO. 8 SCHOOL. Built in 1868 on Hatmaker Road, this school was converted into a residence after its closing.

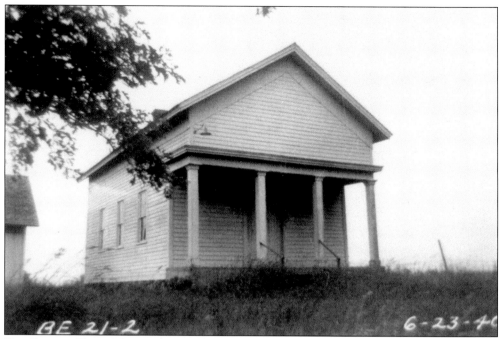

THE BETHEL TOWN HALL. This small town hall was built in 1858 and is still in use today as a voting center. Bethel was originally called Elizabeth because an early settler, Moses Olmstead, came from Elizabeth, New Jersey. By 1838, the name was changed to Bethel.

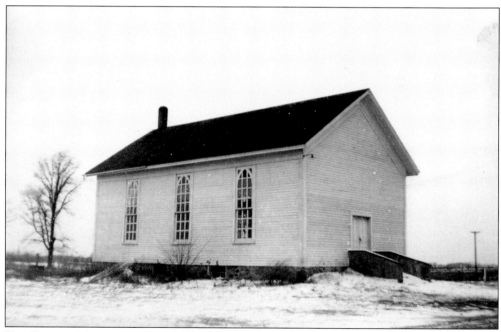

THE BETHEL METHODIST CHURCH. This church was built in 1863 on Snow Prairie Road. It is shown here in 1940. The church is still standing today.

Three
THE SOUTHWEST CORNER

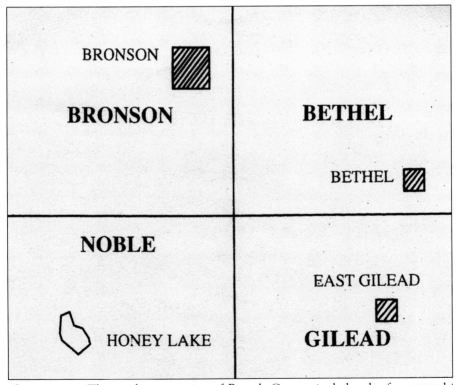

THE SOUTHWEST. The southwest section of Branch County includes the four townships of Bronson, Bethel, Nobel, and Gilead. The Village of Bronson was established in 1866, named after its first settler, Jabez Bronson.

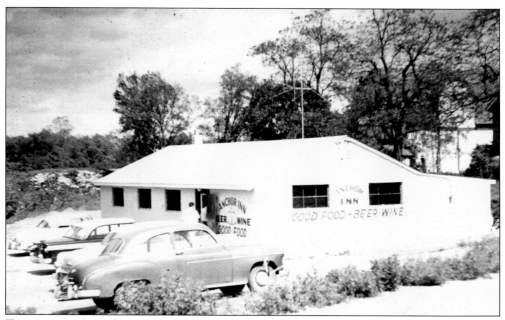

THE ANCHOR INN, OVID. Situated on Coldwater Lake, this small restaurant is depicted in 1957. (Courtesy Jeff Culy.)

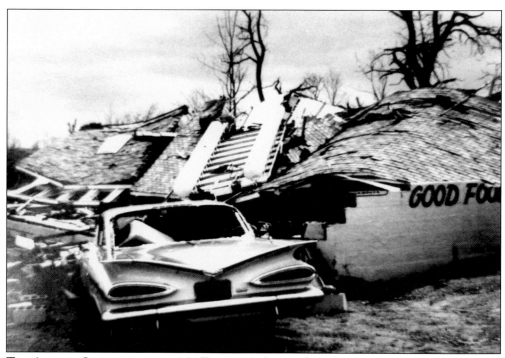

THE ANCHOR INN AFTER THE 1965 TORNADO, OVID. The twin tornadoes on Palm Sunday in 1965 destroyed many homes, businesses, and farms. In this photograph, the "Good Food" sign is still legible. The 1959 Chevrolet seems to have parked too close.

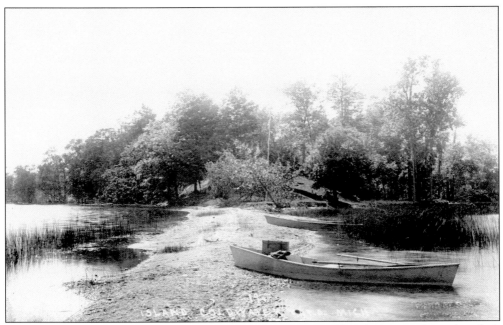

THE SANDBAR, OVID. Off the island at Coldwater Lake is a sandbar that is popular with today's boaters. It is depicted here around 1910.

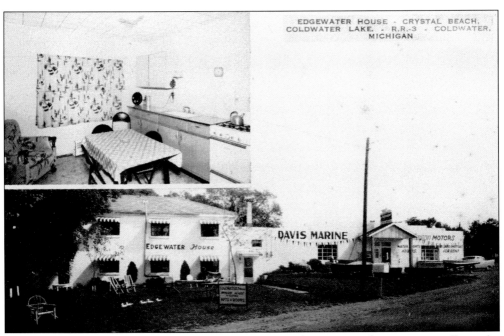

DAVIS MARINE, OVID. Hank and Van Davis owned a marina business as well as the Edgewater House apartments and rooms to rent. This building was destroyed by the 1965 Palm Sunday tornadoes.

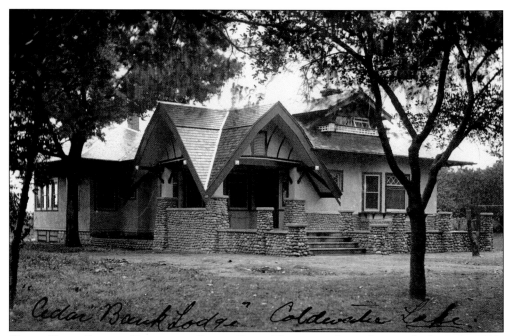

CEDAR BANK LODGE, COLDWATER LAKE, OVID. This stucco bungalow was built in the 1920s and had an incredible stone front porch. Unfortunately, it was destroyed by the 1965 Palm Sunday tornadoes.

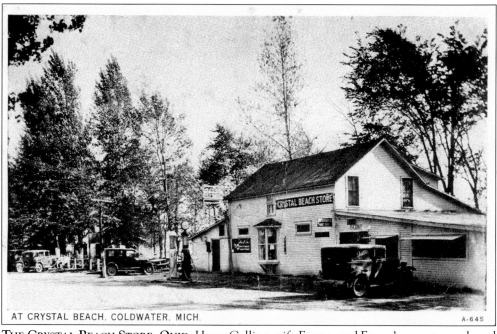

THE CRYSTAL BEACH STORE, OVID. Harry Collins, wife Emma, and Emma's parents purchased the Crystal Beach Store from Verney and Wimmina Stetler in 1924.

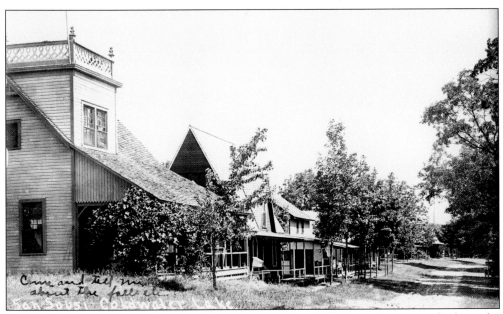

SAN SOUSI BEACH, COLDWATER LAKE, OVID TOWNSHIP. These cottages were built in the mid-1880s along the eastern shore of Coldwater Lake, called San Sousi. The list of the first residents reads like a virtual "who's who" of Coldwater businessmen: L. M. Wing, J. F. Pratt, I. N. Clark, J. B. Shipman, J. H. Buggy, C. H. Dickinson, Roll Chandler, B. S. Tibbits, Allen Pratt, Uri Blodgett, H. C. Clark, and L. B. Palmer. Some of the names of their cottages were Hall of Justice, Ranche 10, Ours, Hope Chapel, Little Comfort, and Pioneer. This photograph was taken around 1910.

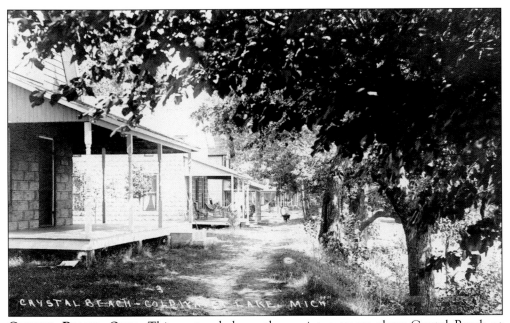

CRYSTAL BEACH, OVID. This postcard shows the quaint cottages along Crystal Beach at Coldwater Lake. Many of these cottages remain, though most have been remodeled to become year-round homes.

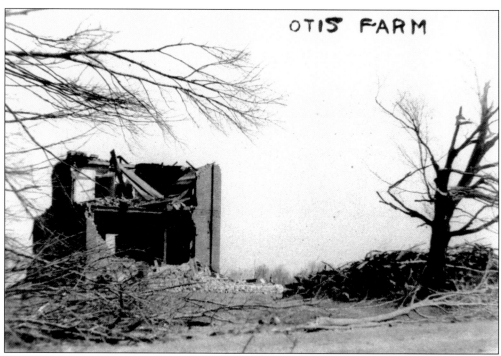

THE OTIS FARM, OVID TOWNSHIP. The 1920 tornado damaged several farms, churches, and school buildings. Another tornado took a similar path through Ovid Township on Palm Sunday in 1965.

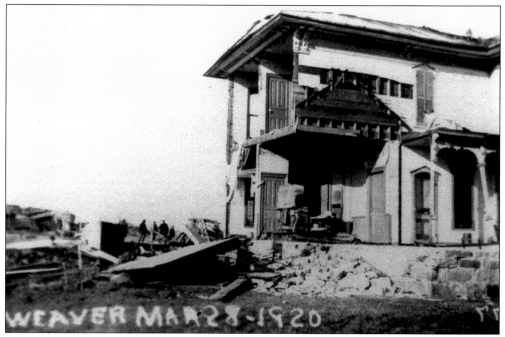

THE TORNADO OF 1920, OVID TOWNSHIP. Shown is the Weaver home after taking a direct hit from the tornado of March 28, 1920. Other farms damaged were the Otis farm, the Heisrodt farm, and the Conklin farm. Numerous school and church buildings were also affected.

THE FENN SCHOOL, OVID AND COLDWATER DISTRICT NO. 3. Built in 1867, this brick schoolhouse is located at the junction of Fenn Road and Route 27. The schoolchildren who attended this school lived in Ovid and Coldwater Townships. The school survives today as a residence.

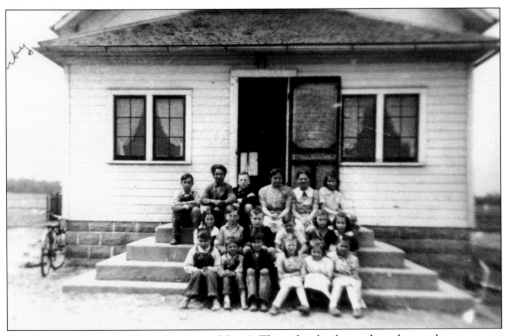

THE QUIMBY SCHOOL, OVID DISTRICT NO. 6. This school is located on the southwest corner of Warren and Quimby Roads. The building has been converted into a residence and survives today. This photograph was taken around 1940.

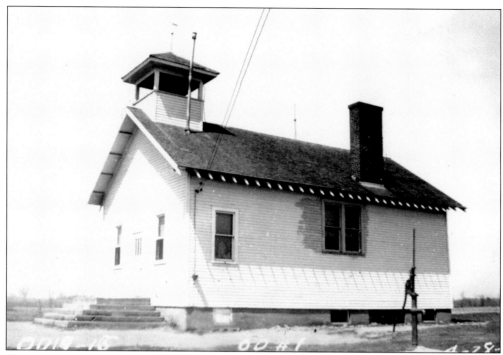

THE OVID DISTRICT NO. 1 SCHOOL. This wooden school was built in 1925. It is shown here in 1940.

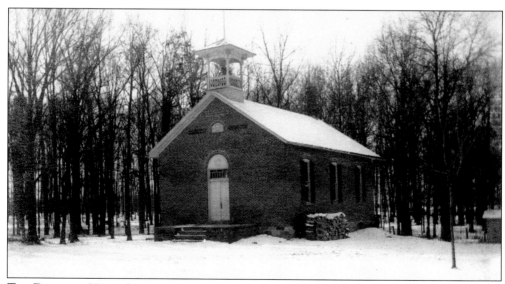

THE DISTRICT NO. 3 SCHOOL, WEST OVID. This brick schoolhouse was built in 1898 on the southwest corner of Central and Behnke Roads. It was called Grub School.

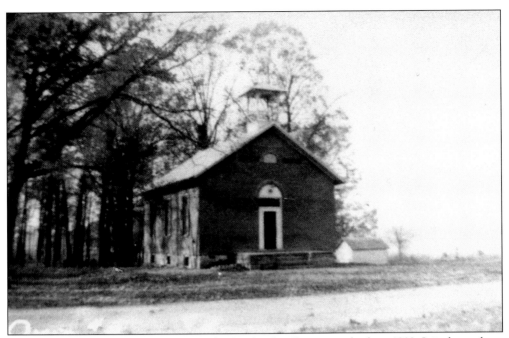

THE OVID DISTRICT NO. 3 SCHOOL. This brick schoolhouse was built in 1892. It is shown here in 1938.

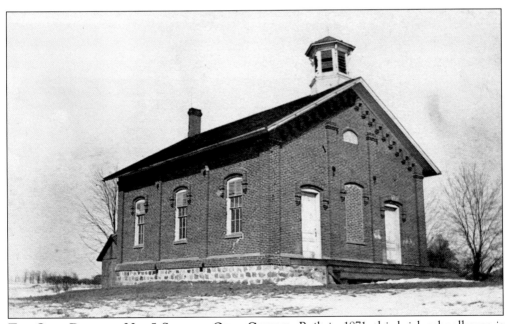

THE OVID DISTRICT NO. 5 SCHOOL, OVID CENTER. Built in 1871, this brick schoolhouse is located on Central Road just west of Route 27. It has been converted into a residence and still survives today.

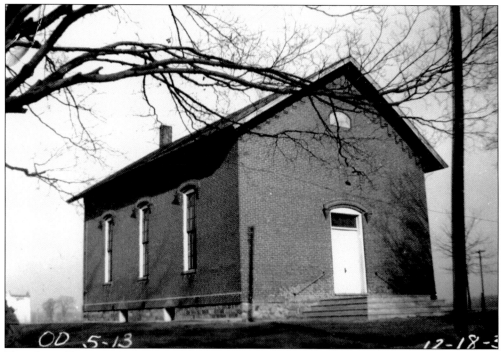

THE FIRST BAPTIST CHURCH, OVID. Built in 1871, this church is now commonly known as the Lockwood Community Church. The congregation disbanded in 1895, and the building sat empty for 12 years. It reopened in 1907 after renovations and repairs. After another dissolution in 1918, the church opened again in 1926 after more repairs. Major additions were made in 1969, adding 10 acres and a new parsonage to the church.

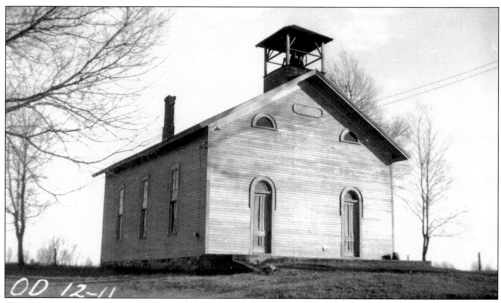

THE UNITED BRETHREN CHURCH, EAST OVID. Built in 1870, this church was originally located on the corner of Quimby and Kern Roads. It was later moved to another location on Quimby, a quarter mile north of Central Road. The first pastor was John Johnston.

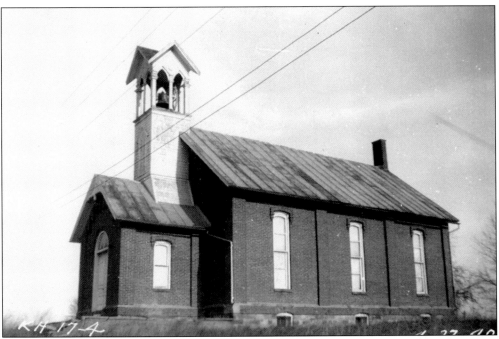

THE FIRST FREEWILL BAPTIST CHURCH, WEST KINDERHOOK. This church was built in 1882 and was destroyed in 1965 during the Palm Sunday tornadoes.

THE KINDERHOOK BAPTIST CHURCH. The Baptists built this church in 1869. They merged with the Methodists in 1922 because of declining membership in both churches, and the church's name was changed to the Congregational Church. Today it is the Michiana Calvary Fellowship.

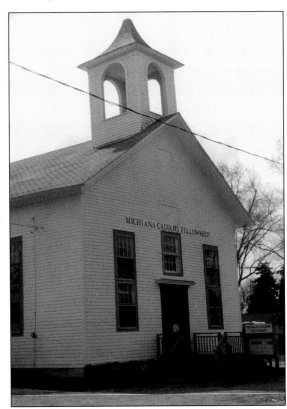

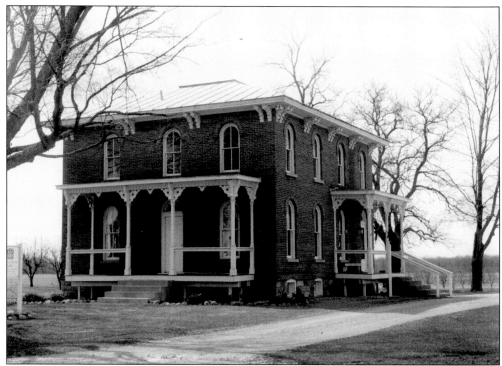

THE CONKLIN RESIDENCE, KINDERHOOK. This brick Italianate home was built in 1860 for James D. Conklin. The Conklins lost their barn in the 1920 tornado. Located just south of the four corners on Route 27, this old farmhouse sat empty from 1978 to 1994. It was then restored, and Jack and Annette Graef opened a store here in 1999 called Early Era Gifts and Gallery.

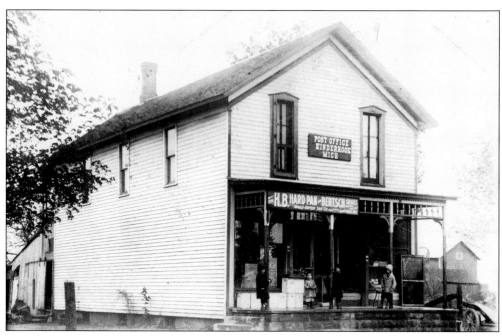

HOYT'S GENERAL STORE, KINDERHOOK. This store also served as the post office.

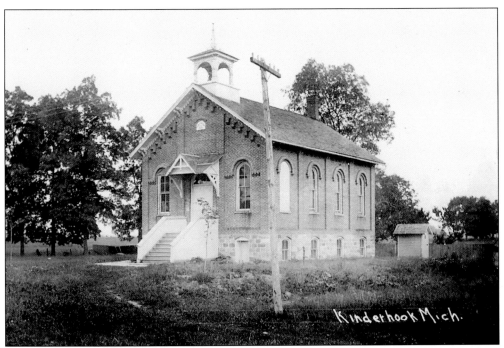

THE KINDERHOOK DISTRICT NO. 1 SCHOOLHOUSE. Located east of the four corners, this school was converted into a residence after it closed. It is currently unoccupied.

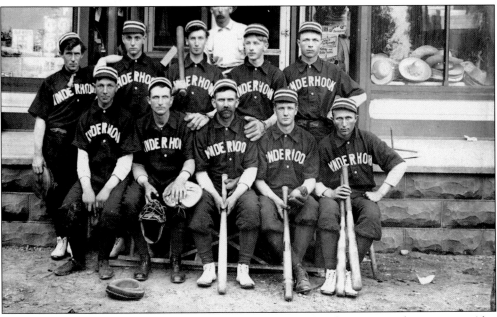

THE KINDERHOOK BASEBALL TEAM, c. 1910. Manger Joe Smith is seen in the very rear. Also pictured are, from left to right, the following: (first row) Jay Baker, Bert Rasey, Herb Spade, Nelson Nye, and Ed Yockey; (second row) John Echues, Leo Sidel, Lyle Flint (with bat), Claude Michael, and Lester Barracks. (Courtesy Jeanine James.)

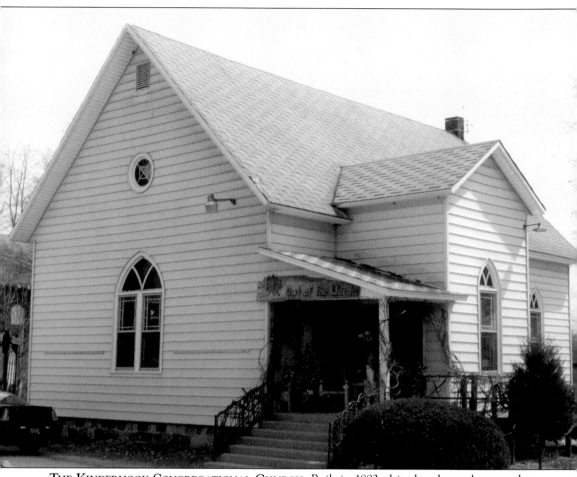

THE KINDERHOOK CONGREGATIONAL CHURCH. Built in 1893, this church was later used as a Grange hall and a town hall. It now houses a retail store. It is located east of the four corners, next to the brick schoolhouse.

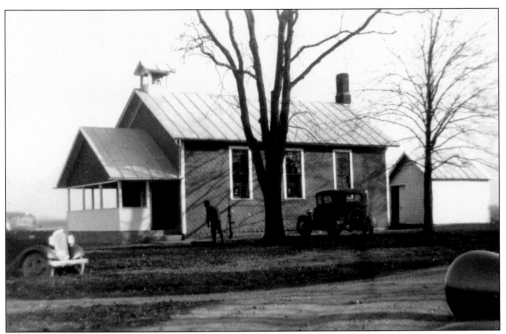

THE CALIFORNIA DISTRICT NO. 1 SCHOOL. This school, shown here in 1937, closed its doors in 1959, and the children were bussed to Reading, Michigan. California Corners was originally called Hall's Corners after Joseph Hall, the first local merchant, who arrived in 1846.

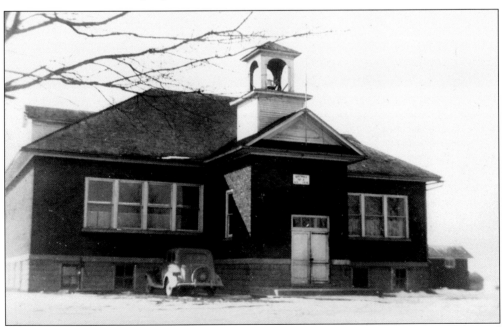

THE RAY SCHOOL, CALIFORNIA DISTRICT NO. 8. Built in 1916–1917, this school featured two classrooms, an auditorium, and a full basement. The school was built through the efforts of Reverend Jack of the Covenanters Church, and for many years, it was known as "the house that Jack built." It closed in 1961, and the schoolchildren were bussed to Quincy schools. The building was sold at auction and was used for storage; it was later converted into a residence.

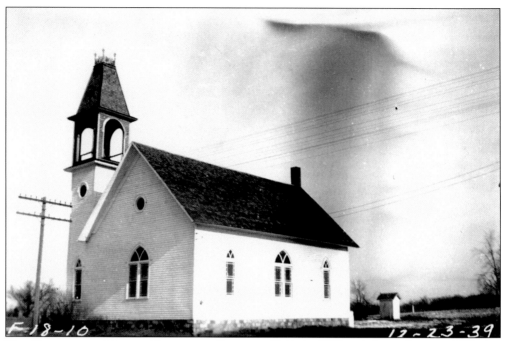

THE CALIFORNIA UNITED BRETHREN CHURCH. Built in 1873 and shown here in 1939, this church no longer exists.

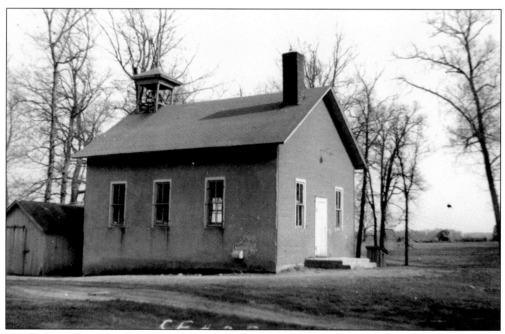

THE BROWN SCHOOL, CALIFORNIA. Built in 1872, this schoolhouse was located on Brown Road.

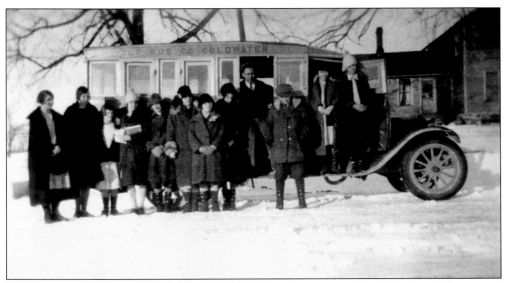

THE WOLF BUS LINE. Schoolchildren were bussed to larger towns for high school. The typical one-room schoolhouse only educated children through the eighth grade.

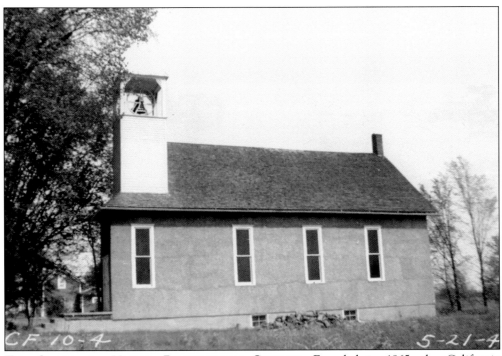

THE CALIFORNIA UNITED PRESBYTERIAN CHURCH. Founded in 1865, the California Presbyterians built this church in 1888. The first reed organ was installed in 1909, and a furnace was added in 1914. This photograph was taken in 1940.

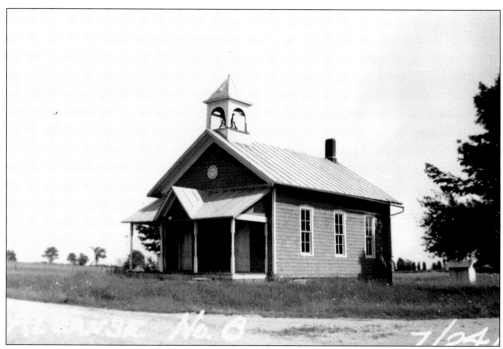

THE ALGANSEE DISTRICT NO. 8 SCHOOL. This brick schoolhouse was built in 1872. It is seen here in 1935.

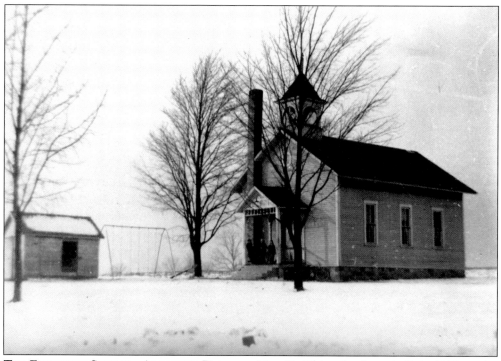

THE FERGUSON SCHOOL, ALGANSEE DISTRICT NO. 11. This school was built in 1889 on the property of Amos C. Bray. It is shown here in 1940.

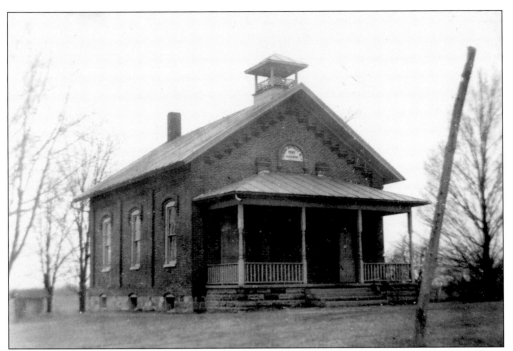

THE ALGANSEE DISTRICT NO. 1 SCHOOL. This brick school was built in 1876 and is shown here in 1939. The Kellogg Foundation updated these one-room schoolhouses in the 1930s with indoor plumbing and new windows.

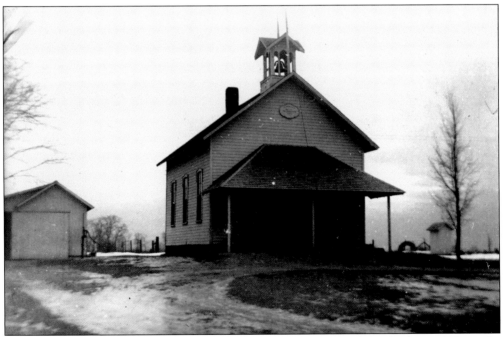

THE JORDEN SCHOOL, ALGANSEE DISTRICT NO. 13. This school was built in 1883 on the southeast corner of Briggs and Fisher Roads.

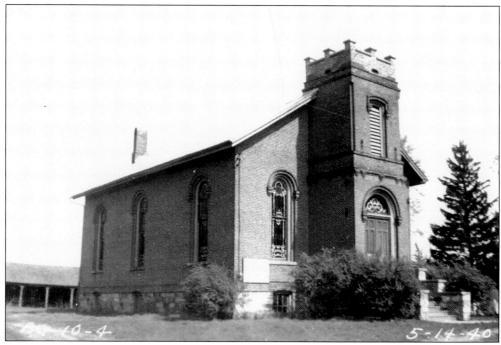

THE FISHER HILL METHODIST CHURCH. Built in 1870 in Algansee Township, this church could hold 300 people. Samuel H. Keeler donated the site, and the builder was C. B. Newton. The church originally had a much larger steeple. The church is now vacant and boarded up. This photograph is dated 1940.

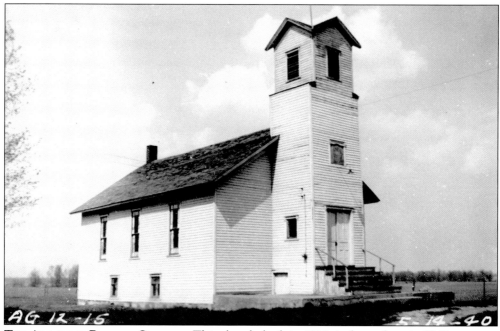

THE ALGANSEE BAPTIST CHURCH. This church, built in 1892, is shown here in 1940.

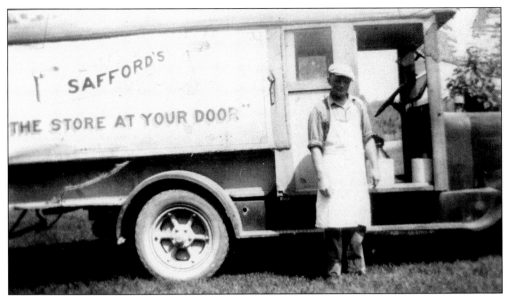

SAFFORD'S DELIVERY BY TRUCK. Safford's store delivered groceries up until the mid-1960s. Shown is driver Roy Wilkerson in the mid-1920s.

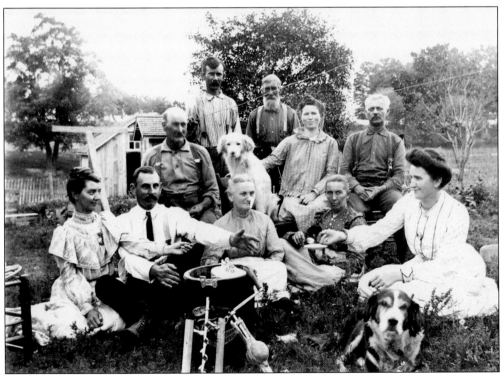

MAKING HOMEMADE ICE CREAM, ALGANSEE. Pictured on the Safford farm are, from left to right, the following: (first row) Darr VanAtta, Lottie VanAtta, Phoebe Stevens, Clara Safford, Dora Safford, and Safford family dog Jack; (second row) Horace Stevens, Walbridge family dog Rover, Cora Walbridge, and Frank Safford; (third row) Burt Walbridge and Jonathan From. (Courtesy Joy Wood.)

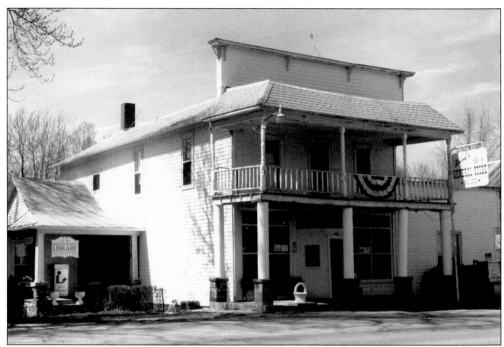

SAFFORD'S STORE, ALGANSEE. This store was built around 1900 by Fred Fulkerson. Ora Safford purchased the store in 1906 and operated it until his death in 1936. His daughter and son-in-law, Gwendolyn and Roy Dove, then ran the store. Recently their daughter Joy Wood has taken over for her parents. Ora Safford came up with the "Store at Your Door" idea, packing his wagon full of groceries and delivering them door-to-door.

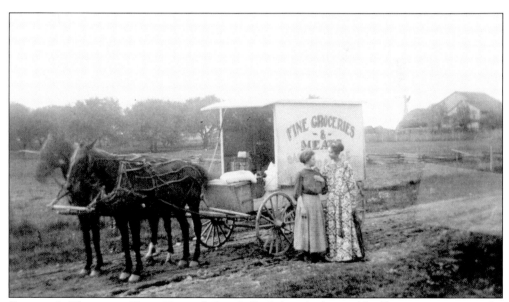

SAFFORD'S "STORE AT YOUR DOOR." Ora Safford thought he could sell more groceries in the rural setting of Algansee by offering a delivery service that would bring his store to the farmers. This c. 1910 photograph shows a stop at the farm of Mason George.

Two

The Southeast Corner

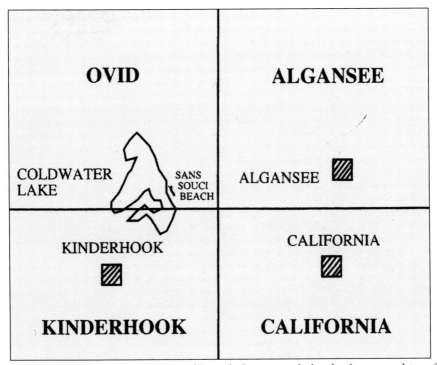

The Southeast. The southeast section of Branch County includes the four townships of Ovid, Algansee, Kinderhook, and California.

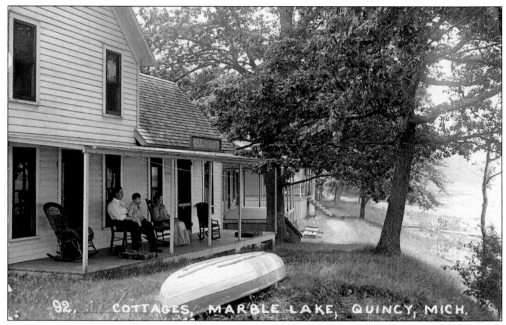

CEDAR POINT, MARBLE LAKE. Two Oaks cottage is shown here around 1910. These homes were strictly for summer use. Eventually these cottages were added on to and winterized and became year-round homes.

THE PLEASANT RIDGE HOTEL, MARBLE LAKE. The Southern Michigan Holiness Camp Meeting Association of the Methodist Church of Quincy built this hotel in 1906. The association held revivals, hosted bands, and offered camps for young people. The Methodist church camps closed by 1944 due to declining numbers of campers.

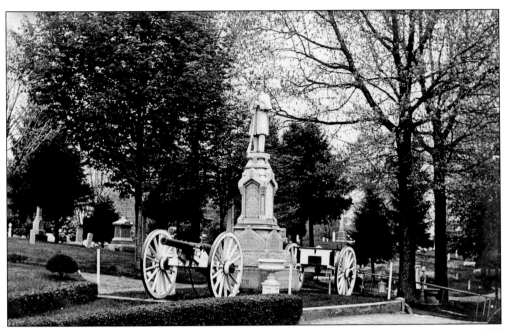

LAKEVIEW CEMETERY, QUINCY. Opened in 1868, the cemetery was named Lakeview in 1877 by newspaper publisher A. C. Culbver. Shown is the entrance to the cemetery and its Civil War monument and cannon.

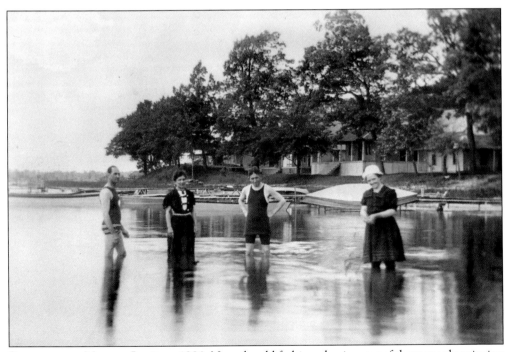

SWIMMERS AT MARBLE LAKE, c. 1890. Note the old-fashioned swimwear of these people enjoying a dip at Marble Lake.

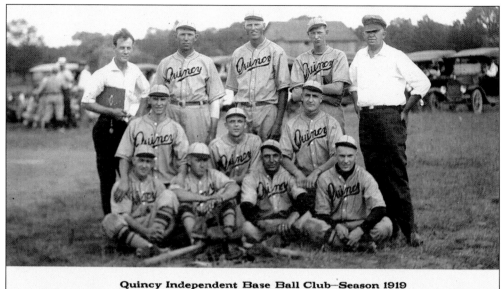

Quincy Independent Base Ball Club—Season 1919
Standing—Sebring, scorer; L. Kulow, 3d; W. Kulow, rf; C. Kulow, 1st; Waterstraut, umpire. Kneeling—Yoder, c-cf; Gilcrist, playing manager; Burgdorf, business manager, p-lf. Sitting—Fillmore, treasurer, 2nd; Bowman, p-ss; Johnson, c-cf; Bowerman, p-lf.

THE QUINCY INDEPENDENT BASEBALL CLUB. This photograph shows the 1919 team. Pictured are, from left to right, the following: (first row) Fillmore, treasurer and second base; Bowman, pitcher and shortstop; Johnson, catcher and center field; and Bowerman, left field; (second row) Yoder, catcher and center field; Gilchrist, playing manager; and Burgdorf, business manager, pitcher, and left field; (third row) Sebring, scorekeeper; L. Kulow, third base; W. Kulow, right field; C. Kulow, first base; and Waterstraut, umpire.

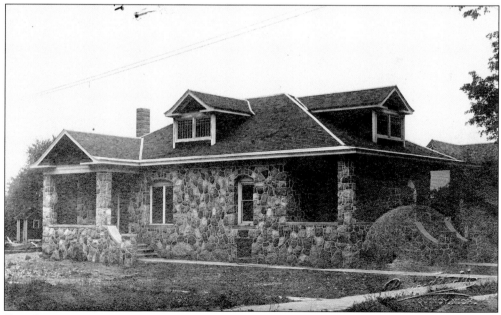

THE CHARLES CRAWFORD HOME, QUINCY. Located at 31 North Main Street, this beautiful fieldstone bungalow, built around 1910, survives today. Charles Crawford was the first owner, and Tom Akins was the second. This photograph is dated 1912.

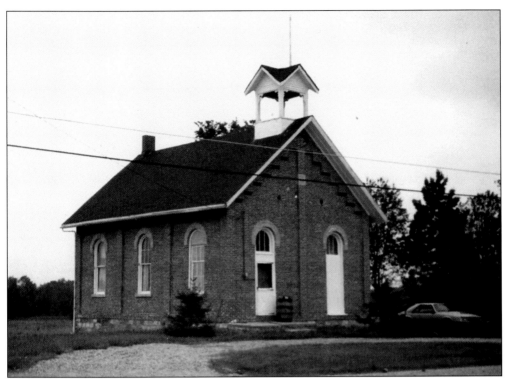

THE LUSK SCHOOL, DISTRICT NO. 3. This school was located on the south side of Route 12, halfway between Coldwater and Quincy. It was later used as a residence.

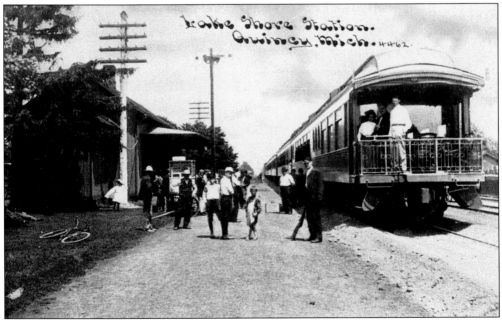

THE TRAIN DEPOT, QUINCY. This wooden train depot was built in 1868 and closed on March 1, 1962. Abandoned and left to the weather, the empty building was torn down in 1979. Trains came to Branch County in the 1850s, and passenger service ended in 1956.

THE QUINCY SCHOOL. Built in 1846, this one-room schoolhouse may have been Quincy's first. It measured 18 feet by 22 feet and was originally located on the site of the Quincy train depot. When the trains came to town, the building was moved to the northeast corner of West Chicago and Church Streets, where the Methodist Church now stands. It was moved a few more times before Elmer Dobson, in cooperation with the Branch County Historical Society, transferred it to its current location on the 4-H fairgrounds, where it is now used as a museum.

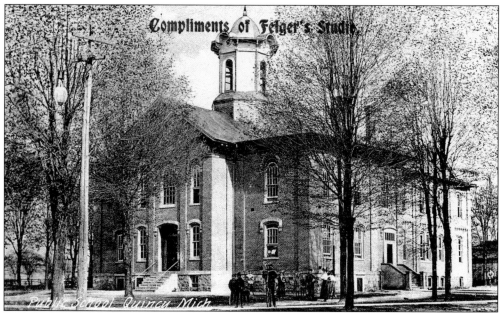

A PUBLIC SCHOOL, QUINCY. This fine brick two-story school was built in 1858 and served Quincy until it was replaced in 1930. Located on the southeast corner of South Jefferson and Fulton Streets, it housed all grades, including high school.

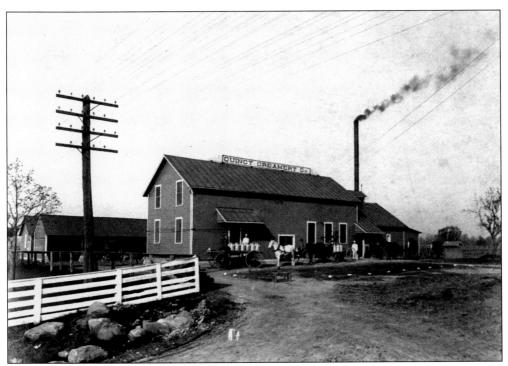

THE COOPERAGE FACTORY. This barrel factory was located on Arnold Street. This photograph was taken around 1890.

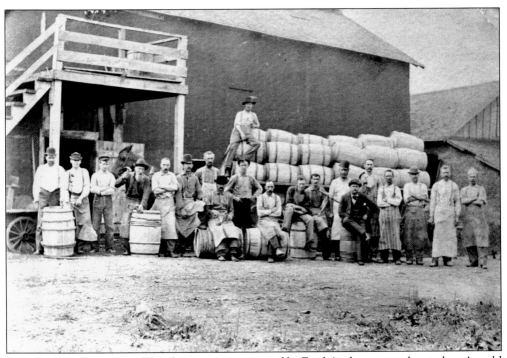

THE QUINCY CREAMERY. This dairy creamery, owned by Emil Anderson, was located on Arnold Street. The main product was butter. This photograph was taken around 1900.

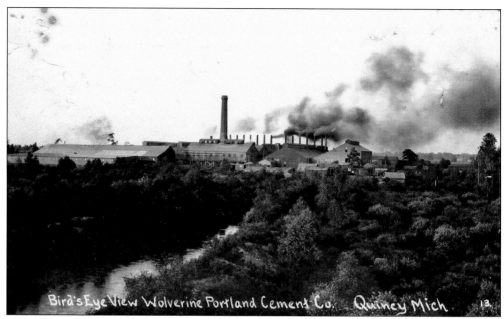

THE WOLVERINE PORTLAND CEMENT COMPANY. Quincy's largest employer was the cement plant located on Tip-up Island. Established in 1899, the Quincy plant had a sister plant in Coldwater that had been established in 1897. To produce high-quality cement, marl was dredged from the lakes, then mixed with clay and put in kilns to dry. Some of the Quincy cement was used for the foundation of the Marshall Field store in Chicago and to pave Calumet Avenue in Chicago. The plant closed its doors in 1947.

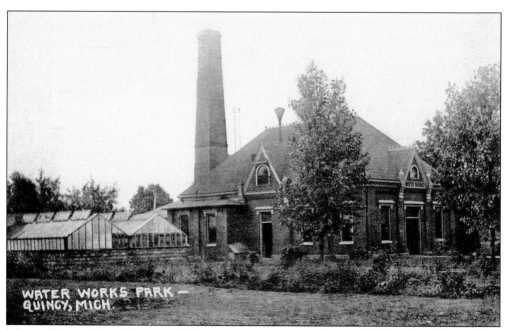

WATER WORKS PARK, QUINCY. A city water system was in place in 1894, and an electric plant was up and running in 1898. Steam-driven generators were originally used, but they were later replaced with diesel engines.

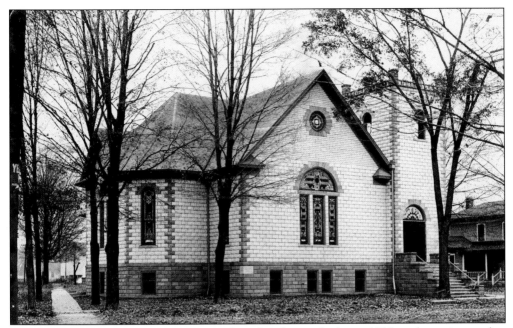

THE METHODIST CHURCH, QUINCY. This church was built in 1908 and survives today. Methodists first started meeting in Quincy in 1836. By 1855, they had built their first church at a cost of $1,800.

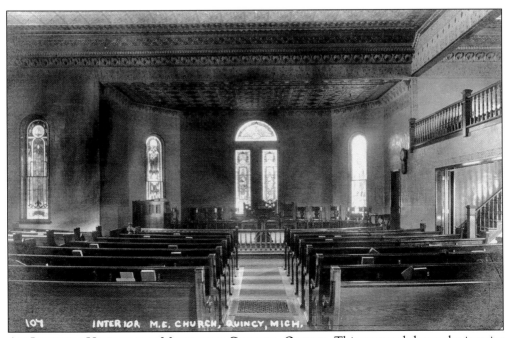

AN INTERIOR VIEW OF THE METHODIST CHURCH, QUINCY. This postcard shows the interior of the 1908 Methodist Church in Quincy. The pastor was Rev. G. A. Buell.

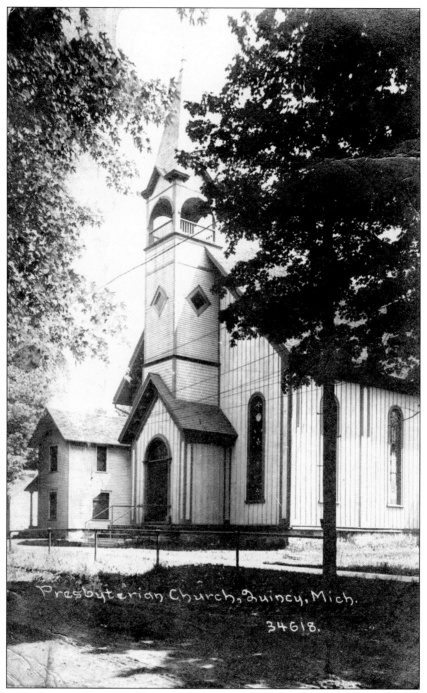

THE PRESBYTERIAN CHURCH, QUINCY. Built in 1869 and added onto in 1879, this church had a bell tower added in 1882 by local carpenter Elmer Dove. In 1914, the Baptists and the Presbyterians joined together because of declining membership in both churches and formed the Union Church of Quincy. In 1925, the bell from the Baptist church was placed in the belfry of the Union Church. In 1928, the Baptist Church was sold to an oil company and was torn down. The Union Church survives today in the Old Presbyterian Church.

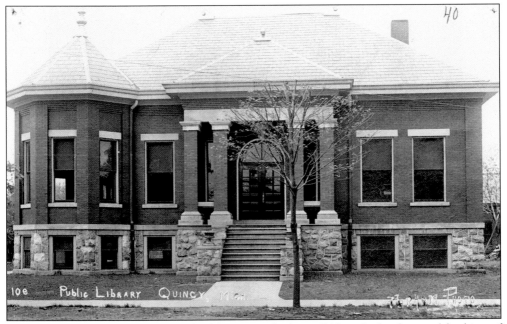

THE PUBLIC LIBRARY, QUINCY. The library was built in 1910 with the financial backing of Charles W. Bennett (1838–1926) and local banker Melvin S. Segur. By 1947, the Quincy library joined the Branch County Library System. A historical marker was placed in front of the library in 1988.

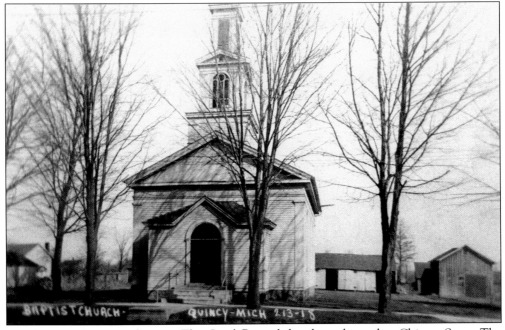

THE BAPTIST CHURCH, QUINCY. This Greek Revival church was located on Chicago Street. The Baptists joined the Presbyterians in 1914, and this church was sold and torn down in 1928.

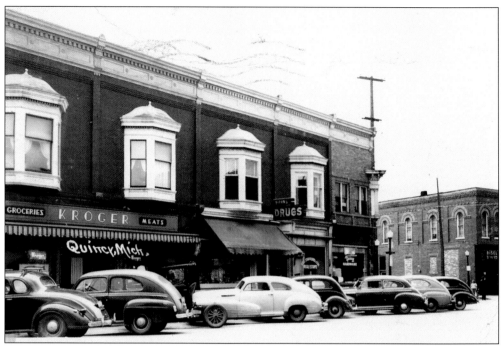

THE KROGER GROCERY STORE, QUINCY. This photograph shows the south side of Chicago Street. Pictured are the Kroger Grocery Store, Mains Drug Store, a real estate office, and Quincy Hardware (on the corner). Across the street in the old bank building, the Bisel and Son 5¢ to 10¢ store is also visible.

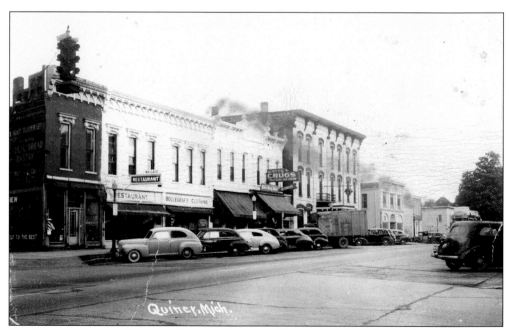

THE NORTH SIDE OF CHICAGO STREET, LOOKING EAST, 1940. The Quincy businesses shown here are Sam's Barber Shop, Wallace's Restaurant, Bollegraf's Clothing, Corless Cleaners, Watt's Drugs, and the Quincy House Hotel.

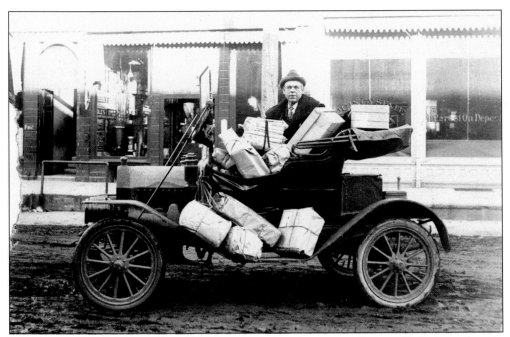

A Quincy Mail Carrier. Elvin Foster was a rural mail carrier in Quincy. He is shown here in 1911 in front of the Quincy State Bank.

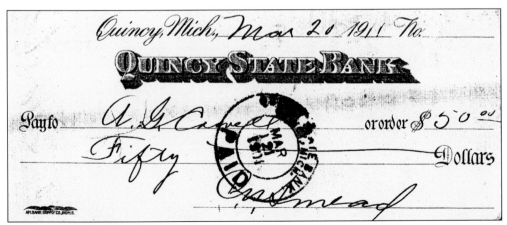

A Check from Quincy State Bank. This canceled check from the Quincy State Bank is dated March 20, 1911. Located at 10 West Chicago Street, the Quincy State Bank merged with the First National Bank of Quincy in 1926.

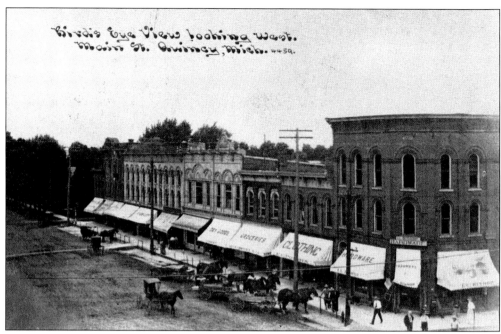

A BIRD'S-EYE VIEW OF QUINCY, LOOKING WEST. This c. 1905 postcard shows the north side of Chicago Street. The building on the corner is I. L. Bishop Hardware; it is now the Stables Restaurant.

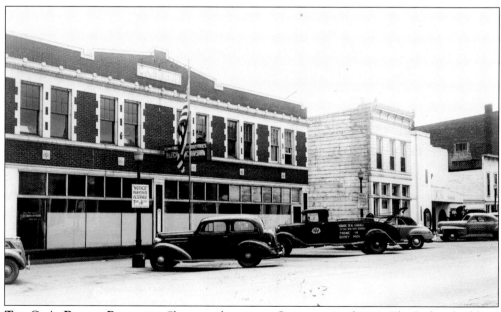

THE C. A. BISHOP BUILDING. Shown is downtown Quincy around 1942. The Bishop building, which later housed part of Crotty Corporation, suffered a disastrous fire in 1973. The Quincy Fire Department now claims this site. The tow truck in this photograph is from Square Deal Garage in Quincy.

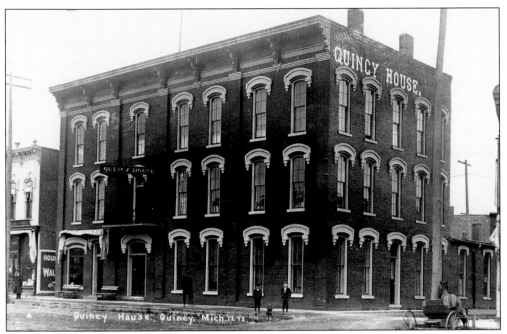

THE QUINCY HOUSE HOTEL. Built in 1878, this three-story brick hotel was an impressive landmark. A fire in November 1973 left no options for the building; it was razed, and the site is currently being used as a parking lot.

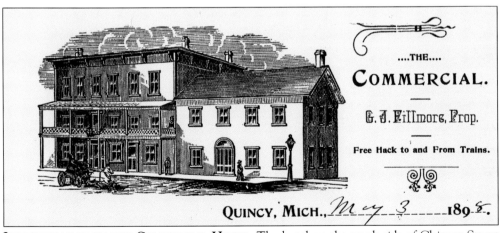

LETTERHEAD FROM THE COMMERCIAL HOTEL. The hotel on the south side of Chicago Street was known as the Commercial and was owned by G. J. Fillmore. This line-cut drawing was used on the hotel's letterhead. It is dated May 3, 1898.

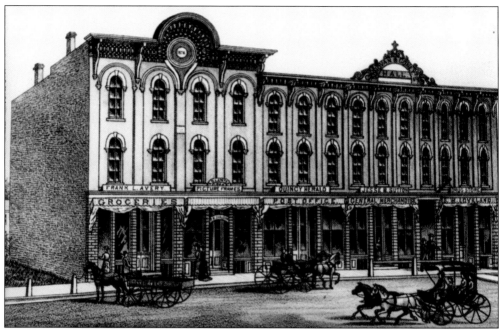

DONOVAN AND CONLY'S BLOCK. This drawing depicts the north side of Chicago Street in downtown Quincy. These buildings were built in 1876. The businesses are listed as follows: Frank L. Avery, groceries; a picture frame shop; the post office, the *Quincy Herald* newspaper; Jesse B. Sutton, general merchandise; and Loveland Drug Store.

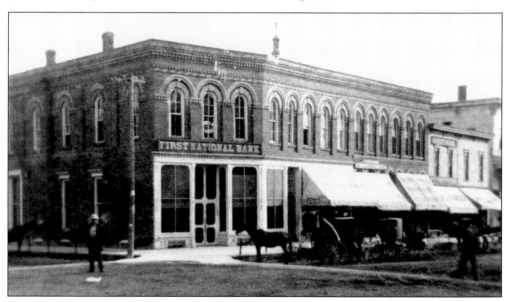

THE FIRST NATIONAL BANK OF QUINCY. The First National Bank of Quincy was organized on July 13, 1881. Its first officers were B. F. Wheat, president; John H. Jones, vice president; and Charles Hannon, cashier. A merger in 1926 with the Quincy State Bank enabled the First National Bank to move across the street to the present office of First of America Bank-South Central. This photograph was taken around 1900. The building has been razed, and a gas station now sits on this corner.

THE BUTLER METHODIST CHURCH. This church, located on Herricksville Road, was built in 1880. It is seen here in 1940.

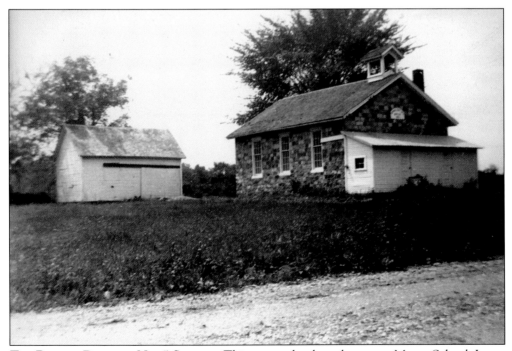

THE BUTLER DISTRICT NO. 5 SCHOOL. This stone school was known as Moore School. It was built in 1871 and was located on Moore Road. The school closed in 1955, and local children were bussed to the Quincy schools.

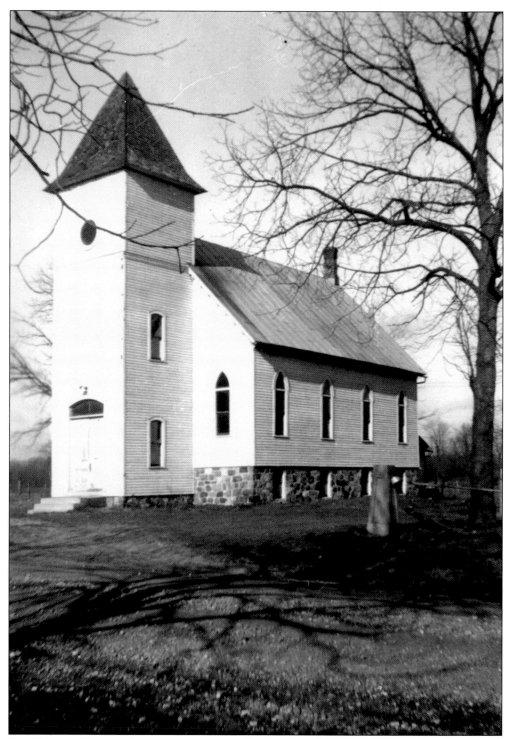

THE BUTLER BAPTIST CHURCH. Located on Dayburg Road, the First Baptist Church was built in 1854 and was replaced by this church at the same location in 1898. This photograph is dated December 8, 1939.

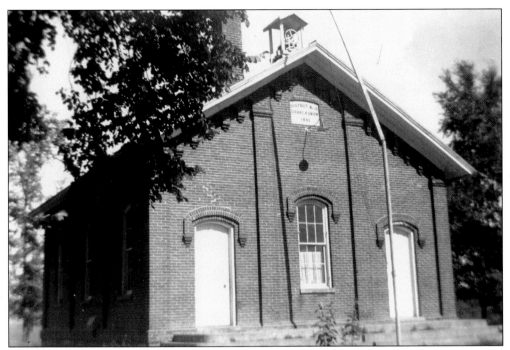

THE GIRARD DISTRICT NO. 10 SCHOOL. The Cornell School was built in 1881 on the east side of Hodunk Road. It survives today as a storage building. In 1878, there were 10 school buildings in Girard Township: two of brick, four of wood, and four of stone. The schools were named Russell, Gorball, Girard, Hodunk, Bidwell, Benson, Smith, Cobblestone, Grub Oak, and Cornell. Some of these schools have been converted into residences.

THE DECKER HOME, BUTLER TOWNSHIP. This log cabin was located one mile west of Butler Village on the south side of the road. Other settlements in Butler Township included Faxon, Knowlesville, and Herricksville.

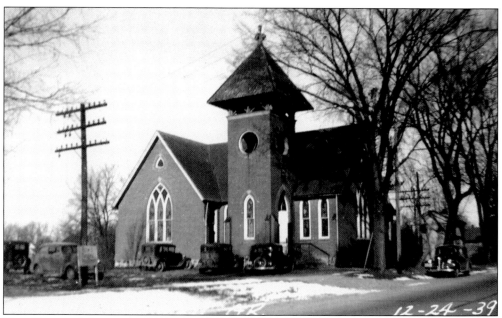

THE GIRARD METHODIST CHURCH. Built in 1888, this church replaced a wooden structure that had been built in 1844 and had burned in 1887. This brick building was constructed by J. R. Simmons of Union City, and it survives today with a few additions and modifications. Richard Corbus was the first to settle in Girard in 1829.

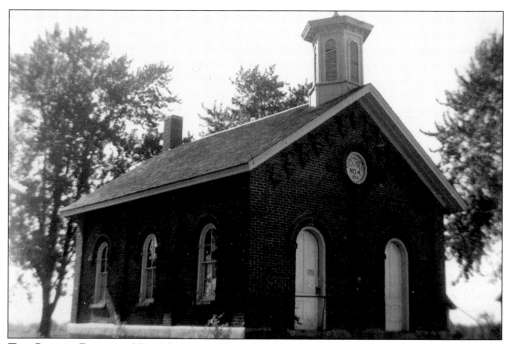

THE GIRARD DISTRICT NO. 4 SCHOOL. This school, built in 1875, was named the Smith School. There were approximately 125 one-room schoolhouses in Branch County, most of which closed in the 1950s and 1960s, when school districts consolidated and children living in the townships were bussed into town.

THE GRUB OAK SCHOOL. This stone one-room schoolhouse was built in 1869 and closed in 1966. Located on Herricksville Road in Girard Township, it survives today and has been added onto in the front.

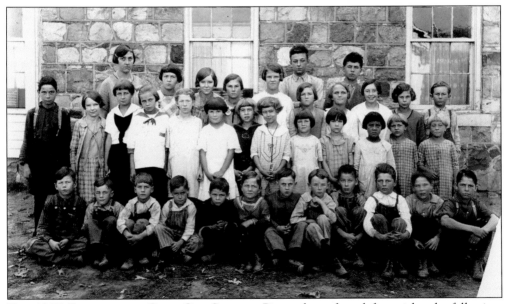

THE 1925 CLASS OF THE GRUB OAK SCHOOL. Pictured are, from left to right, the following: (first row) Robert George, Lewis McElhenie, Russell Eldred, Paul Saltzgaber, Andy Gallup, Maurice Wagoner, Elon Eldred, Warren Taylor, Rex Saltzgaber, Floyd Wagoner, Orville Gallup, and Charles Gallup; (second row) Clifford Gallup, unidentified, Helen Rigg, Nellie Manchester, unidentified, Lettie Manchester, Mildred Okeneske, Marie Semmelroth, Margaret Kawalske, Edith Rigg, an unidentified Native American girl, Blanche Tomas, and Bessie Thomas; (third row) teacher Rachel Downey, Flossie Manchester, Ardella Rigg, Cecelia Tobalske, Cecelia Okeneske, Violet Tobalske, Helen Okeneske, Celia Semmelroth, Leola George, and Bernard Tobalske; (fourth row) Walter Thomas and Lynn Manchester.

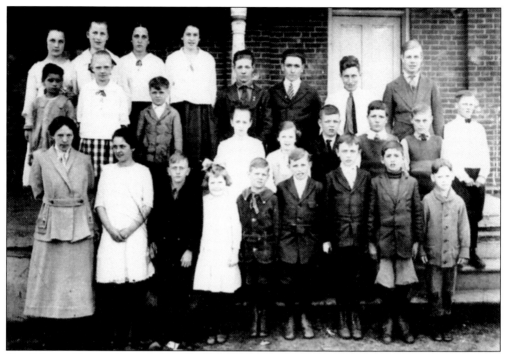

THE MAPLE GROVE SCHOOL, DISTRICT NO. 10, COLDWATER TOWNSHIP. This brick one-room schoolhouse was built in 1867 and closed in 1963. Located on Sanford Road, it survives today as a storage building. Shown here in 1914 are, from left to right, the following: (first row) teacher Fern Bickford, Mary Widener, Clarence "Tom" Batterson, Leona Wolcott, Millard Thomas, Leland Sanford, Herman Behnke, Joe Barone, and Kenneth Luther; (second row) Catherine Barone, Dorotha Lockwood, Joe Tinervia, Joyce Batterson, Ruth Forrester, Clark Thomas, Harold Widener, Forest Kanpp, and Wayne Wilson; (third row) Opel Alleshouse, Athlene Wolcott, Lucene Batterson, Lucile Stevens, Clyde Thomas, Paul Widener, Duane Sanford, and Milford Forrester.

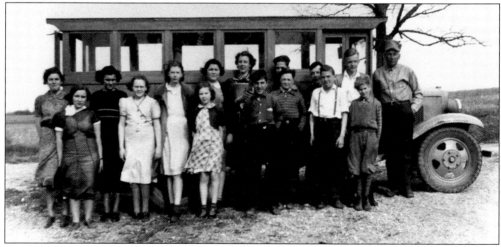

A 1930s SCHOOL BUS DRIVER. Archie Smith was a school bus driver in the 1930s and was responsible for transporting children to Coldwater City schools.

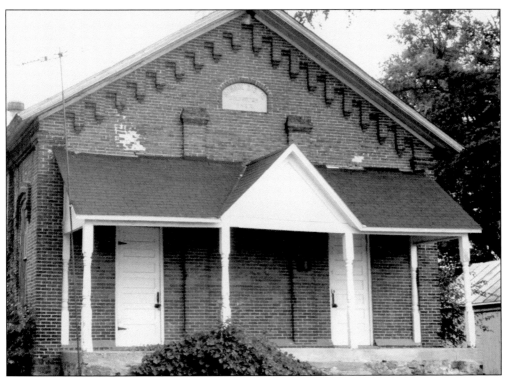

THE FOX SCHOOL, DISTRICT NO. 15. Built in 1873, this brick one-room schoolhouse closed in 1958. Located on the southeast corner of Fiske Road and Dorrance Road, it was sold to Henry Dove and later to E. Landis. The building survives today.

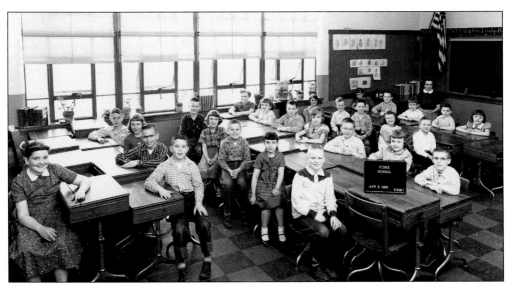

THE FISKE SCHOOL, DISTRICT NO. 7. This interior view is dated April 6, 1956. The Fiske School was located on the southeast corner of East Chicago Street and Fiske Road. Polly Mason donated the land, and A. C. Fiske lived across East Chicago Street. It is presumed that A. C. Fiske paid for the construction of the building. The schoolhouse was damaged by fire in the late 1930s, and the building was rebuilt. It was razed in 2004 to make way for a new office building.

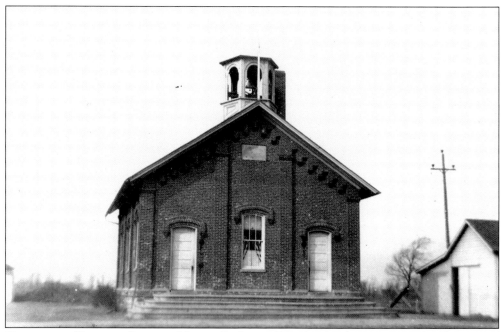

COLDWATER BRANCH SCHOOL NO. 1. Built in 1870, this brick one-room schoolhouse was located on Branch Road near the present-day airport. The school no longer exists.

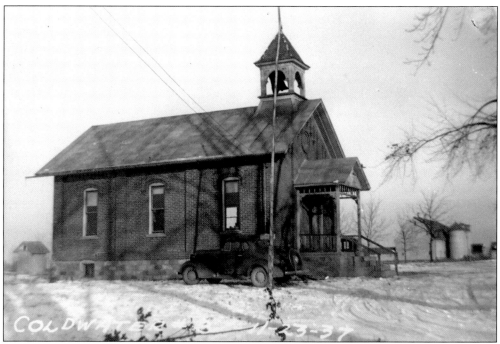

THE SCOVILLE SCHOOL, DISTRICT NO. 8. This brick school was built in 1880 and survives today as a home. It is located on Dorrance Road just before the I-69 overpass.

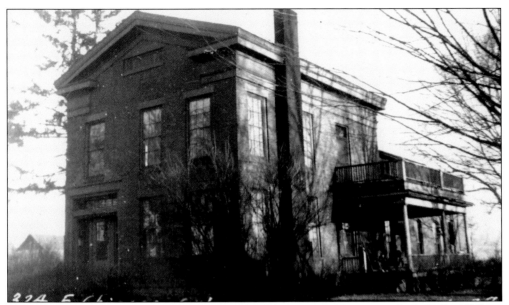

THE DR. WILLIAM SPRAGUE HOME. The first brick house in Coldwater was built for Dr. William Sprague in 1840. The brick mason was Ebenezer Mudge, and the bricks came from the Barnabus Wing Brickyard. This Greek Revival home was located at 324 East Chicago Street, where the main entrance to the Community Health Center of Branch County is now located. The home was torn down in March 1990.

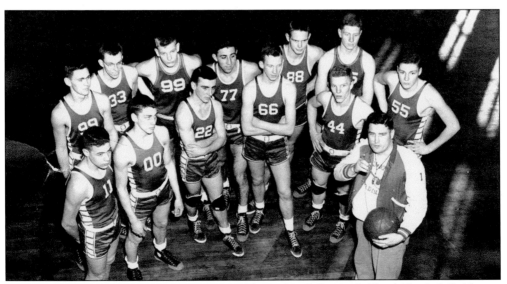

THE 1949 STATE CHAMPION BASKETBALL TEAM. In 1949, coach Floyd Eby led Coldwater High School's class B basketball team to a 49-42 victory over River Rouge with a style of playing labeled "racehorse basketball." This photograph is dated February 9, 1949. Pictured are, from left to right, the following: (first row) Gene Fry (No. 11), Larry Porter (No. 00), cocaptain Gene Sowles (No. 22), Rex Corless (No. 66), Harry Cooper (No. 44), and coach Floyd Eby; (second row) Fred Weeks Jr. (No. 99), Jim Rhodes (No. 33), Bernard Hogenboom (No. 99), Marvin Rosenberg (No. 77), cocaptain Leroy Cox (No. 88), Tom Engle (No. 55), and Max McConnell (No. 55). Not pictured is team member Bob Simmons.

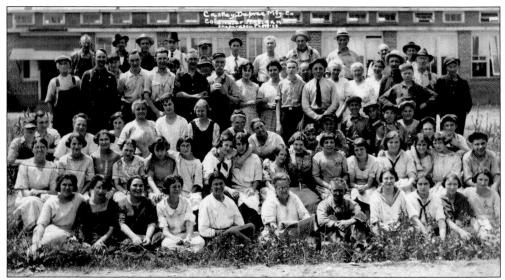

THE CASKEY-DUPREE MANUFACTURING COMPANY. Located at 306 South Clay Street, this building housed the L. A. Darling Company. It was later demolished. The Branch Area Transit Area (B.A.T.A.) bus garage now sits on this site. H. A. Douglas was company president when this photograph was taken in 1923.

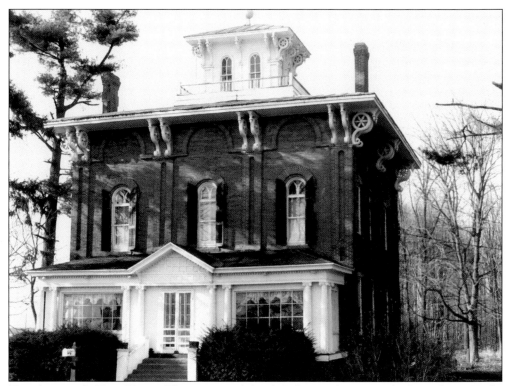

THE ABRAM C. FISK HOME. This mammoth brick Italianate home was built in the 1860s for horse breeder A. C. Fisk. It is located on East Chicago Road in what is now a busy commercial neighborhood. The home was listed on the State Register of Historic Sites in 1979.

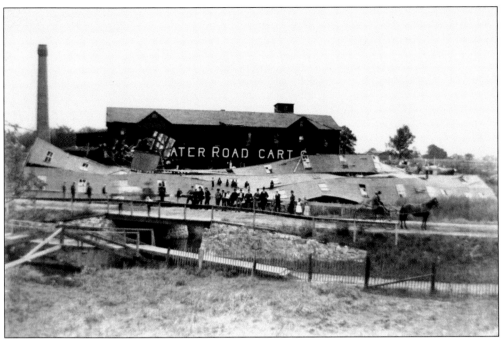

THE COLDWATER ROAD CART COMPANY. This business was located at 260 Division Street. This photograph, dated August 28, 1890, shows the collapse of one of the company buildings.

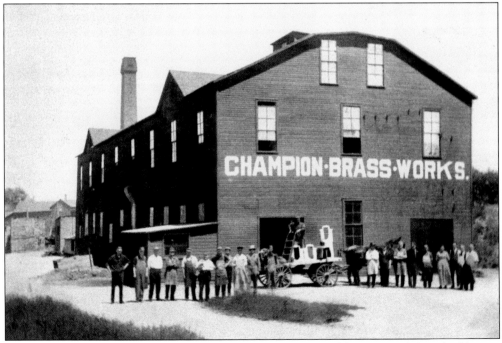

THE CHAMPION BRASS WORKS. Located in the surviving Coldwater Road Cart building at 260 Division Street, Champion Brass Works manufactured hairpins, greening pins, and brass, copper, and iron rivets. R. C. Ratto was president, C. A. Pollack was vice president, and S. G. Feller was secretary and treasurer.

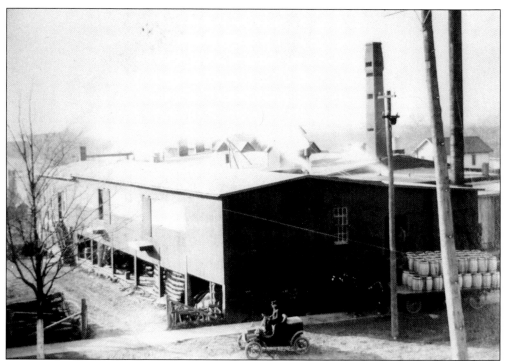

THE JOHNSON COOPERAGE. Charles W. Johnson owned and operated a barrel factory on West Chicago Street at the intersection of West Pearl Street. This photograph was taken around 1910.

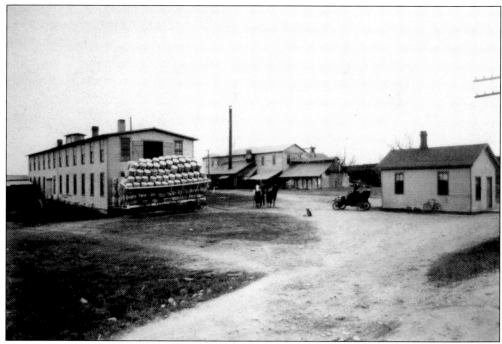

THE CALKINS COOPERAGE. Brazillai H. Calkins and son Marc D. Calkins owned and operated a barrel factory on Race Street. This photograph was taken around 1910.

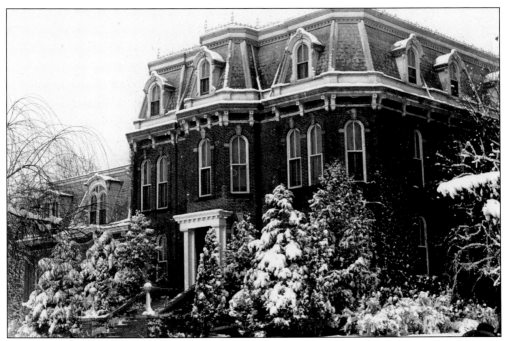

THE STATE PUBLIC SCHOOL. Built in 1873 on 25 acres of land, this school provided facilities for 180 orphaned children. By 1935, the school was converted to a facility for mentally challenged patients, and its name was changed to the Coldwater State Home and Training School. In 1956, a state-of-the-art hospital was added. As social attitudes changed and technology advanced, the facility closed its doors in the 1980s. It is currently the site of a state correctional facility.

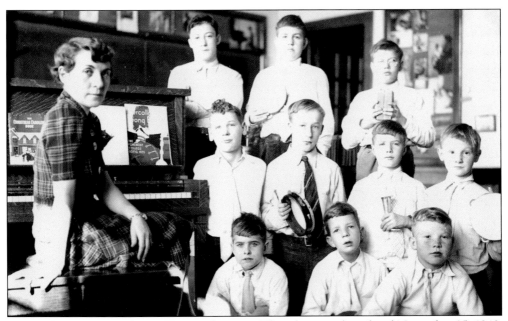

MUSIC CLASS AT THE STATE PUBLIC SCHOOL. This photograph is dated November 25, 1940. Thousands of children were educated at the State Public School during its long and varied history. Most of the buildings were torn down in the 1970s.

STATE SENATOR CALEB D. RANDALL. Senator Randall (1831–1903) served in the Senate in 1870. He was instrumental in bringing the State Public School to Coldwater. The city donated 25 acres and $30,000 and was chosen as the site of the new facility. Randall also helped form the Southern Michigan National Bank in 1872.

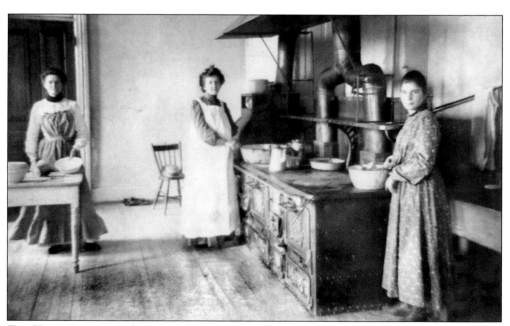

THE KITCHEN AT THE STATE PUBLIC SCHOOL. The kitchen at the State Public School is seen around 1880.

The 1932 Wolverine Archery Catalog. Frederic A. Kibbe established the Wolverine Archery Equipment Company in 1918. The catalog covered a full line of archery needs. Kibbe closed the shop in 1942, when he enlisted in the military to serve in World War II, and never reopened it. He moved to Fort Lauderdale, Florida, in 1949 and retired from the military in 1956 as a lieutenant colonel. He ran for congress in 1962. Kibbe died in the 1980s, leaving his wife, Bertha, and three daughters, Patricia Greene, Marjorie Corey, and Virginia Davenport.

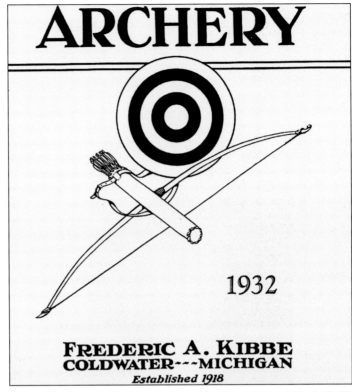

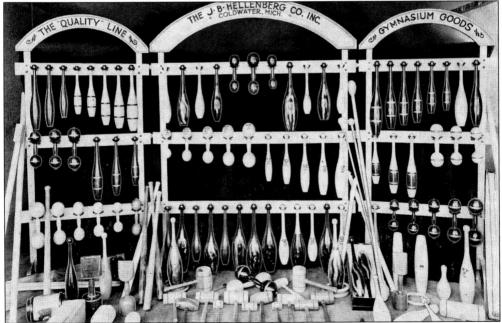

A J. B. Hellenberg Company Catalog. The J. B. Hellenberg Company, established in 1870, was located at 189 South Jefferson Street near the old Midwest Foundry. This catalog page shows the company's vast product line of wooden items, including bowling pins, Indian clubs, dumbbells, school wands, and horizontal bars.

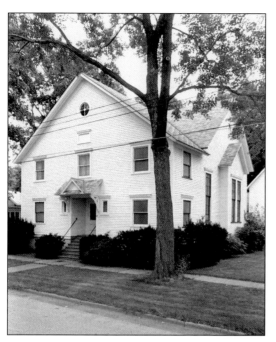

THE WESLEYAN METHODIST CHURCH. Built in 1852, this church is the second oldest in Coldwater. Located at 44 North Hudson Street, it was founded by a small group of people who left the Methodist Episcopal Church because they were strongly against slavery and wanted to help runaway slaves. This church has gone through many renovations and has borne many names, including True Vine Fellowship Church. It is currently called the Church of God.

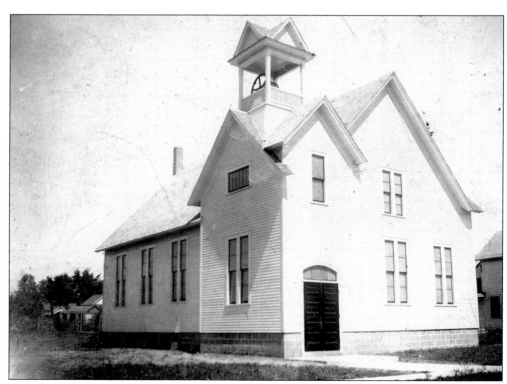

THE FREE METHODIST CHURCH. Located at 129 Perkins Street, this church was built in 1906 and still survives today. The first pastor was D. M. Wells, and the trustees were S. Zeller, G. D. June, and Fred Sutter. The Free Methodists built a new church in the 1960s at 200 North Fremont Street, across from the Coldwater High School.

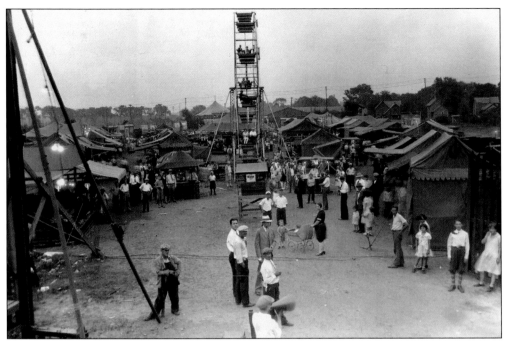

THE BRANCH COUNTY FAIR. This c. 1937 photograph, also featured on the cover of this book, shows the Branch County Fair, located just south of Waterworks Park. Frank L. Flack, who owned the Blackhawk Mills, also worked the carnival circuit with a company called Michigan Greater Shows. A set of rare black-and-white photographs were left in his home and were discovered by the new owners. (Courtesy Diana Gruner [née King].)

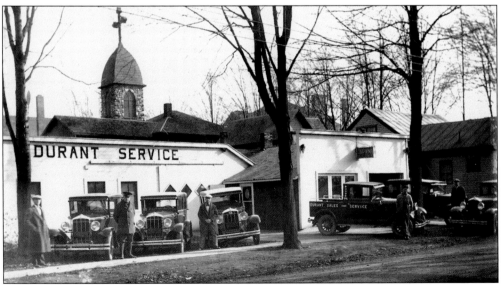

B. C. ARLINGTON'S DURANT SALES AND SERVICE. This business, pictured around 1929, was located at 98 Harrison Street. Pictured are, from left to right, Carl Krimmel, Union City dog warden; C. G. Cole, conservation officer; Ed Brinkley, sheriff; Floyd Ulery, mechanic; and B. C. Arlington, car dealer. The old St. Charles steeple can be seen in the background. B. C. Arlington's daughter, Bette Wagoner, provided this photograph.

A World War I Soldier. Arthur Champion poses in front of Tibbits Opera House just prior to leaving for Europe during World War I. He was a member of Company A of the Michigan National Guard.

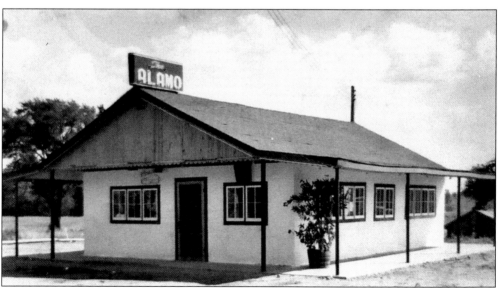

The Alamo Restaurant. Located on the west side of Coldwater, the Alamo, shown here in 1948, had a carport added to the front and became Coldwater's first drive-in restaurant. Teenagers in the 1950s and 1960s used to "cruise the Alamo." It was owned and operated by brothers Carl and Bob Lopez, sons of Nick and Louise Lopez. The building survives today as a meat store.

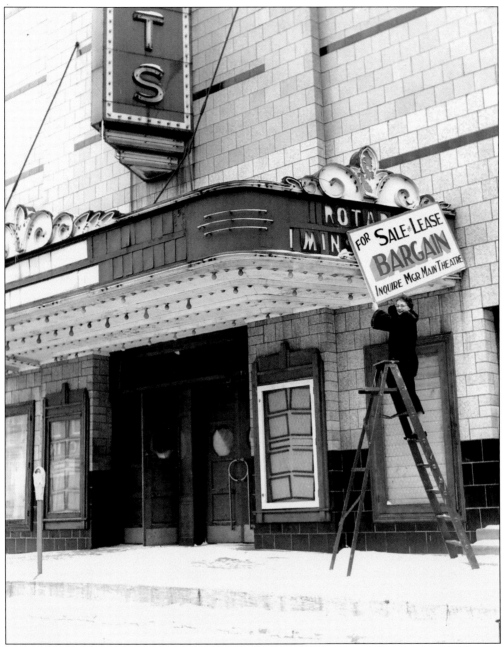

THE TIBBITS OPERA HOUSE, FOR SALE OR LEASE. After of the Main Theatre opened following World War II, the writing was on the wall for the destitute Tibbits, which closed by the mid-1950s. It was saved from being torn down in 1959. This photograph was taken around 1957. Note the 1930s art deco façade and marquee.

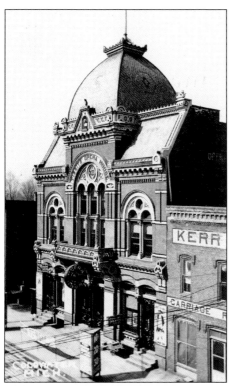

THE TIBBITS OPERA HOUSE. Barton S. Tibbits built this beautiful opera house in 1882 at a cost of $25,000. Mortimer L. Smith was the architect. The opera house is located on South Hanchett Street, across from where the Tibbits Cigar Factory once stood. In the 1930s, an art deco façade was added when the opera house became a movie house. Saved from the wrecking ball in 1959, the Tibbits Opera House is currently undergoing a $10 million restoration. This photograph looks south on South Hanchett Street. The Kerr Brothers' carriage repository building was torn down in the 1970s, and the building south of Tibbits Opera House, a cigar box factory, was torn down in 2005.

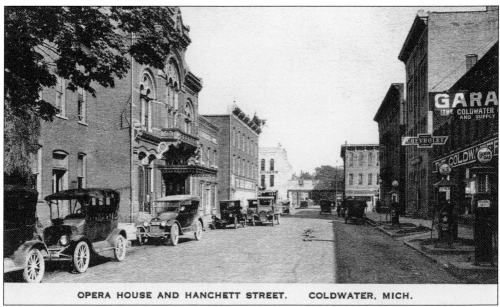

SOUTH HANCHETT STREET, LOOKING NORTH. This two-story building, shown around 1900, was located across the street from the Tibbits Opera House. The businesses it housed in the early 20th century included Brown and Warren; the Opera House Livery; Edgerton and Chadsey, blacksmiths; and Edwin Mansell, plumbing and steam pipe fitter. Several automobile dealerships later occupied this building, including Calhoun Chevrolet in the 1920s and Warner Buick from the 1930s to the 1950s. This building was torn down in the 1960s, and the site is a parking lot today.

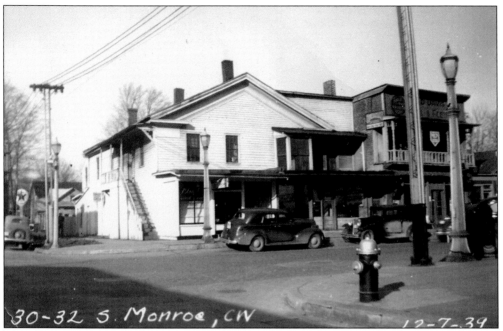

THE ORIGINAL BAPTIST CHURCH. Built in 1844, this Greek Revival church is shown here on December 7, 1939, on the southwest corner of West Pearl and South Monroe Streets. David Norton's auctioning business now occupies this corner. This church was originally located on the northwest corner of West Chicago and North Monroe Streets. The building was moved in 1853, and the original site is now occupied by Monarch Community Bank.

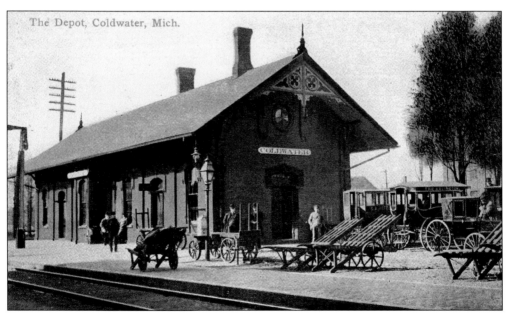

A TRAIN DEPOT. This brick train depot was built in 1883, replacing the wooden structure built in 1850 when the trains came to Branch County. The wooden building was sold to Batavia and still survives today. The brick depot also survives and has been home to several different gift shops. Passenger train service ended in 1956.

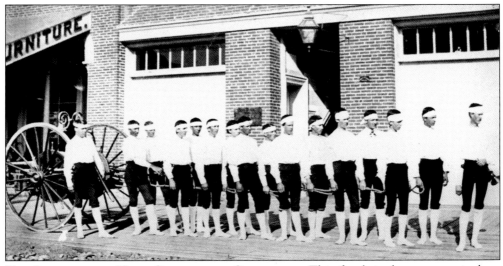

THE INDEPENDENT HOSE COMPANY OF COLDWATER. This fire brigade was organized on December 1, 1871. Members pictured here are, from left to right, the following: (first row) Philo Robinson, Frank Nettleman, Frank Burr, Watson Davis, L. D. Fisk, Andrew Talmage, Charles Flynn, and A. J. Dorrance; (second row) Edward Drake, Charles Rogers, W. G. Crippen, Joseph Boucher, Nelson Doty, Eugene Bailey, John Filkins, and James L. Worden. This photograph was taken at the fire station on South Monroe Street.

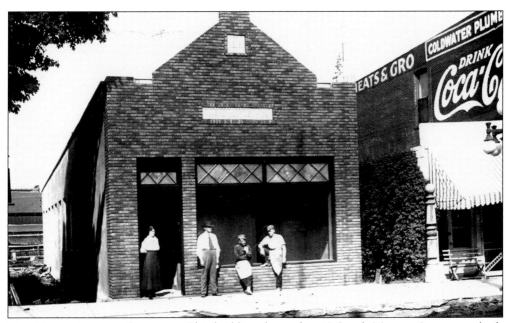

THE MASON-DORSEY COMPANY. This building, located at 18 South Monroe Street, was built in 1919. A later addition to the north doubled the size of the building. The Mason-Dorsey Company manufactured quality monuments; a tour through Oak Grove Cemetery can attest to the company's fine work. The building survives today as Omar's Bar. (Courtesy Lisa Harvey.)

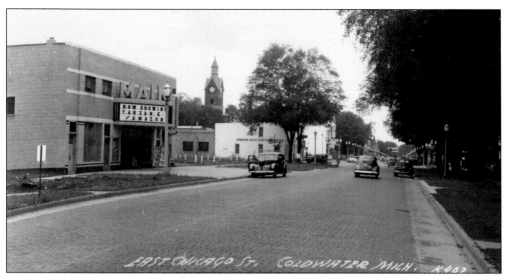

THE MAIN THEATRE. A new state-of-the-art theater opened at 64 East Chicago Street in Coldwater just after World War II. The Main Theatre, seen here around 1948, caused the Tibbits Opera House to close in the 1950s. Vern Brook was the manager at "The Main" for years. The Main Theatre eventually closed when a new multi-screen facility opened near I-69. Note the brick streets, Corson Auto Electric, the Branch County Clock Tower, and the theater's advertisement, which reads "Now Showing . . . Tarzan and the Amazon!" (Courtesy Jeanine James.)

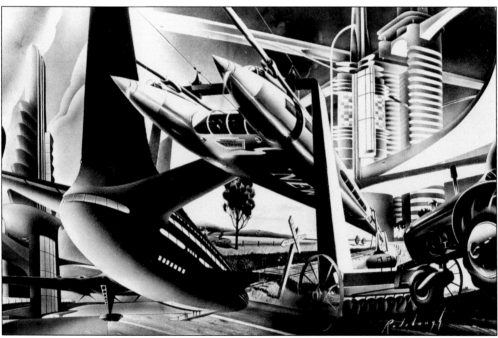

AN ARTHUR RADEBAUGH PRINT. Arthur Radebaugh (1906–1974) was born in Coldwater and became an airbrush artist. His futuristic style became famous, appearing in advertisements for companies like Coke and Chrysler Automotive as well as gracing the cover of magazines such as *Motor*, *Esquire*, and *Fortune*. The print shown here used to hang in the office of the *Coldwater Daily Reporter*.

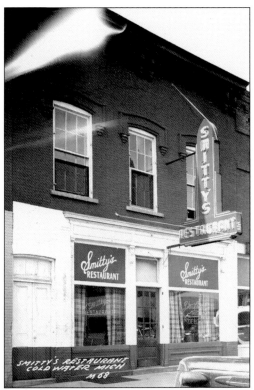

SMITTY'S RESTAURANT. Walter A. Smith owned and operated this restaurant, located at 97 West Chicago Street. He went into business in the 1930s with a restaurant called Two By Four, located at 7 South Hanchett Street. By the 1940s, Smith had relocated to the much larger building seen in this 1947 photograph. The building also served as the Greyhound bus depot. It has been torn down, and Dally Tire Company now sits on this site.

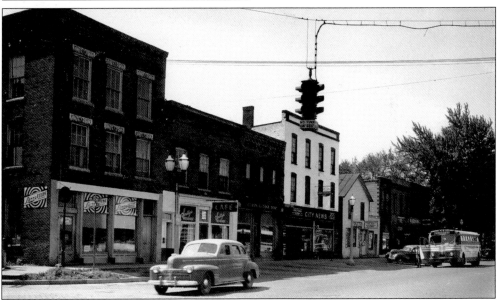

WEST CHICAGO STREET, LOOKING WEST. This mid-1940s postcard view of the southwest corner of West Chicago and South Clay Streets shows a row of buildings that no longer stand. Pictured from left to right are the Conover Printing building (shown here housing a feed store), Smitty's Restaurant at 97 West Chicago Street, Adam's Antique Shop, the City News Stand at 101 West Chicago Street, Russell's Sales (which sold garden tractors), Crandall Tire, Crow and Son Welding, and R. F. Moore implements (which sold farm tractors).

A LUCKY PENNY. This 1929 "wheat" penny is in an aluminum case featuring an advertisement for the Coldwater National Bank. This bank merged with Branch County Savings in 1935 and became Century Bank and Trust.

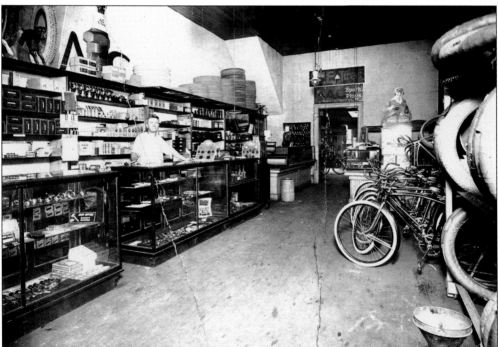

THE W. J. SWEET BICYCLE SHOP. William Jason Sweet is shown around 1934 behind the counter of his shop at 76 West Chicago Street. This building survives today and is home to the State Farm Insurance Company. According to the bicycle shop's advertisement, the store also featured radios, sporting goods, fishing tackle, flashlights, pocket knives, and guns and ammunition, and it also offered a lock repair service.

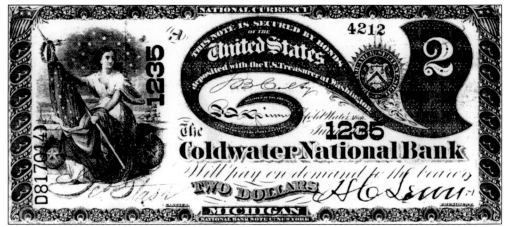

A COLDWATER NATIONAL BANKNOTE. Shown is a national banknote issued around the 1860s by the Coldwater National Bank and signed by George Starr and Henry Clay Lewis. It is called a "lazy" $2 bill because the large number 2 is on its side.

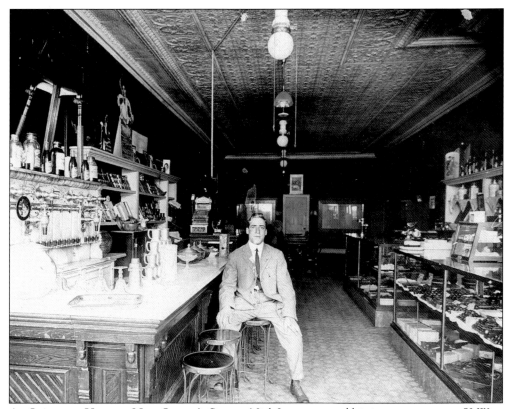

AN INTERIOR VIEW OF NICK LOPEZ'S STORE. Nick Lopez opened his ice cream store at 53 West Chicago Street in 1907. He lived upstairs with his wife and three children. Nick's brother Harry also had an ice cream shop, which he opened in 1911 at 14 West Chicago Street. It was later known as Irma's Restaurant.

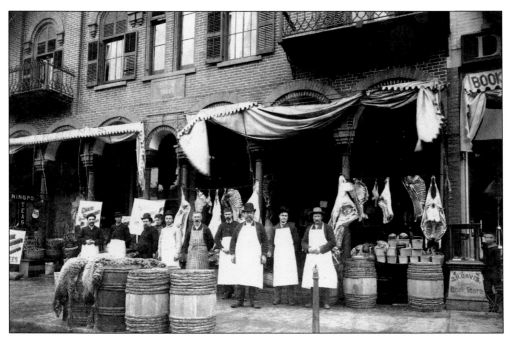

THE C. H. AND R. MILNES GROCERY STORE. Located at 52 and 54 West Chicago Street, this double store was established in 1861 by Henry Milnes. His two sons took over the business in 1878. Son Robert was in charge of the groceries, and son Charles was in charge of the meat department. This building was built in 1869; it underwent a face-lift in 1887 and later had a major renovation to the façade in 1910. Today it is part of Taylor's Hallmark.

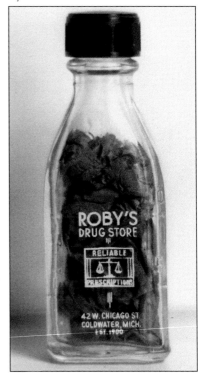

A MEDICINE BOTTLE FROM ROBY'S DRUG STORE. Norman Roby established Roby's Drug Store, located at 42 West Chicago Street, in 1900. Shown is one of the medicine bottles from his downtown store. Norman and wife Florence resided at 73 Grand Street and raised their family there.

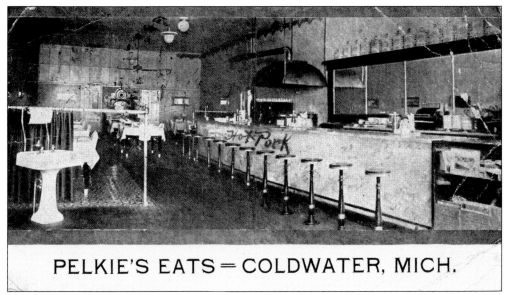

AN INTERIOR VIEW OF PELKIE'S RESTAURANT. Pelkie's Restaurant, owned by J. E. Pelkie and wife Blanche, was located at 37 West Chicago Street. In 1918, it boasted "neat, modern equipment."

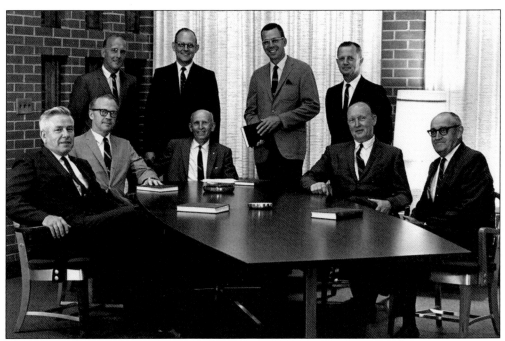

THE BOARD OF DIRECTORS OF BRANCH COUNTY FEDERAL SAVINGS AND LOAN. This c. 1968 photograph features the Board of Directors of the Branch County Federal Savings and Loan Association. Pictured are, from left to right, the following: (first row) Al Obed of Federal Mogul; William Bobier of Legg Lumber Company; accountant Ernest Luce; Chrysler dealer Marion L. Pillsbury; and Charlie Mosher of Farmer's Insurance; (second row) attorney Tom McGargle; George Pierce, president of the Branch County Federal Savings and Loan Association; Clyde Williams of William's Granary; and tire dealer Olin Dally. (Courtesy George Pierce.)

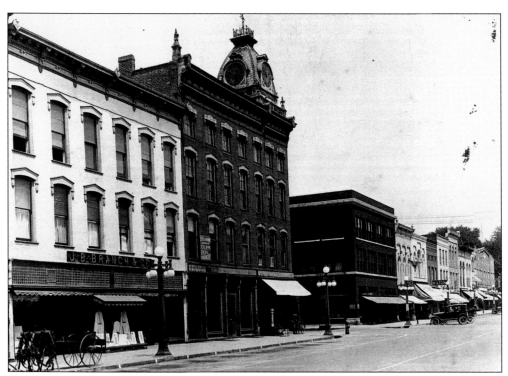

DOWNTOWN COLDWATER. Shown is the north side of West Chicago Street, looking east, around 1922. The first building is J. B. Branch and Company, established in 1877. The building with the clocks at the top is the old bank building, which was razed in 1962 to give way for the Branch County Federal Savings and Loan. Across North Monroe Street is the newly rebuilt E. R. Clarke building, which had collapsed in 1913. This building survives today with the columns and sandstone façade that were added when Coldwater National Bank purchased the building.

HENRY A. WALCOTT. Henry Walcott owned and operated a blacksmith shop with John McNett in Coldwater in the 1880s. He is shown here in his later years with downtown stores as a backdrop.

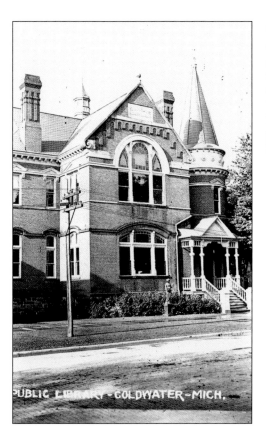

THE EDWIN R. CLARKE LIBRARY. E. R. Clarke was a prosperous downtown merchant who donated funds for a building to replace the town's modest library, which was located in a private home. The new library was built in 1886 by local architect M. H. Parker at a cost of $10,000. The librarian, Mary A. Eddy, achieved prominence in her field and helped found the Michigan Library Association in 1891.

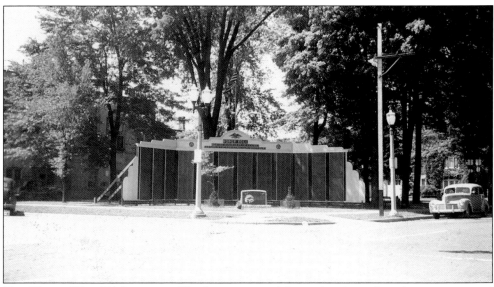

THE WORLD WAR II MEMORIAL. This large memorial, located at the park at the intersection of Routes 12 and 27, listed all the veterans from Coldwater who served their country during World War II

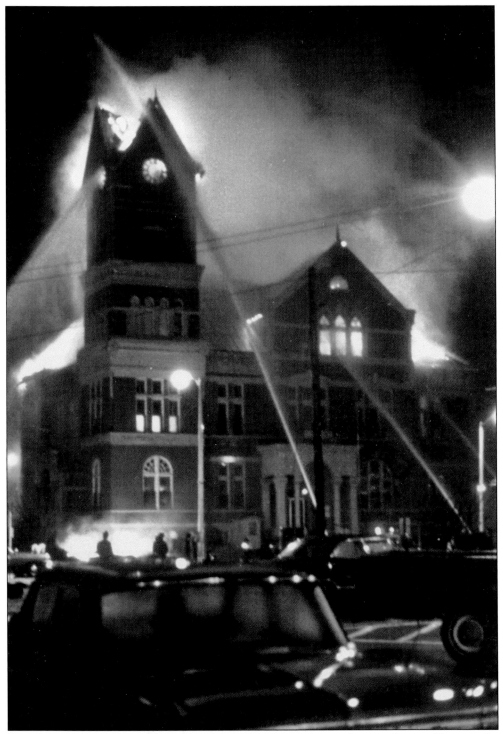

THE COURTHOUSE FIRE, DECEMBER 5, 1972. An arsonist set the courthouse ablaze on the night of December 5, 1972. The building was a total loss; it was replaced in 1976. The clock and bell were salvaged and are now housed in an appropriate tower. (Courtesy Tom Miller.)

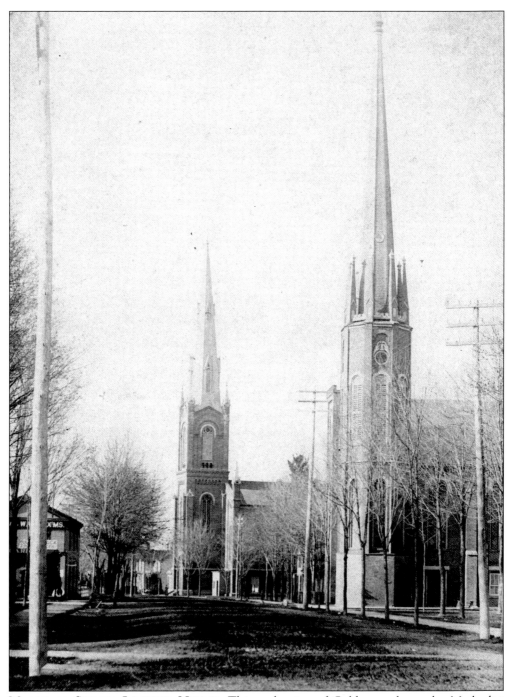

MARSHALL STREET, LOOKING NORTH. This early view of Coldwater shows the Methodist (right) and Presbyterian churches, complete with steeples. The Methodist Church, built in 1865 at a cost of $30,000, later removed the wooden steeple, and the church was replaced in the 1960s. The First Presbyterian Church, built in 1869 at a cost of $40,000, survives today with its 185-foot steeple. It is the oldest church in Coldwater still in use by its original denomination and is considered a historic landmark.

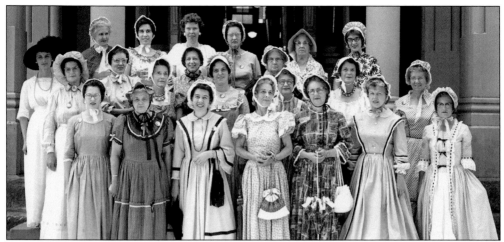

THE COURTING HOUSE BELLES. Coldwater's 100th birthday was celebrated in 1961. This photograph, taken on June 30, 1961, on the north steps of the courthouse, shows all the women who worked in the Branch County Courthouse dressed up in 100-year-old attire for the centennial celebration. Pictured are, from left to right, the following: (first row) Sally Pope, clerk and register of deeds; Margretta Service, deputy register of deeds; Marie Daniels, deputy county clerk; Marie Palmer, social worker, Bureau of Social Aid; Audrey Troutman, bookkeeper, Department of Social Welfare; Lucille King, deputy county treasurer; and Betty Greening, Abstract Office; (second row) Dorothy Mathews, clerk, County Treasurer's Office; Ruth Champion, social worker, Bureau of Social Aid; Maxine Ferry, deputy county treasurer; Zella Stephens, social worker, Bureau of Social Aid; Charlotte Wright, supervisor, Bureau of Social Aid; and Helen Hodgman, Abstract Office; (third row) Onnalee Layman, clerk, Agricultural Office; Colleene Kelly, secretary, County School Office; Mrs. C. Alfred Rice, clerk, County School Office; and Clara Linn, wife of the county clerk; (forth row) Ethel King, clerk, Drain Commissioner's Office; Ruthana Harpham, deputy probate register; Eleanor Patch, clerk, Agricultural Office; Verna Hensch, cataloger, county library; Clara Gordon, custodian; Mary Mathews, clerk, County Treasurer's Office.

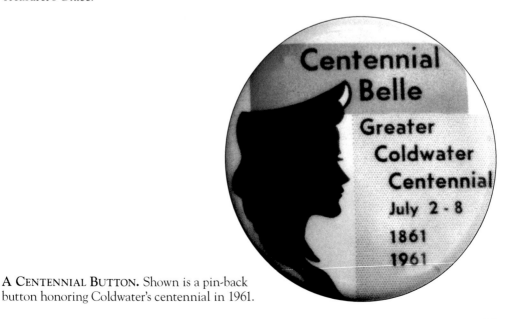

A CENTENNIAL BUTTON. Shown is a pin-back button honoring Coldwater's centennial in 1961.

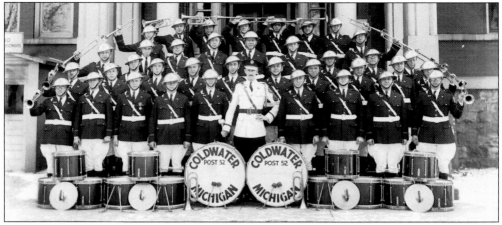

THE COLDWATER POST 52 AMERICAN LEGION BAND. Dated November 13, 1932, this photograph was taken on the steps of the Branch County Courthouse. Pictured are, from left to right, the following: (first row) David Fletcher, Fred Speaker, Daniel E. Bradley, Clare Goss, Herman Myers, Burr Cochran, George Vail, Ward W. Hilborn, Howard Roesier, Paul K. Barber, and Leslie Woodward; (second row) Donald Bajer, Lynn Mains, William Linton, John Youngs, Guy Gridley, John Cochran, Leon R. Wood, Norman G. Kohl, Phil Robinson, and Ralph W. Strong; (third row) Floyd H. Hollister, Bernard Corson, Leon Bridges, Donald H. Edison, LaVern Odren, Raymond Doll, Albert J. Norton, Walter J. Bien, John H. Walker, and Bruce C. Strong; (fourth row) Clyde Corson, Leonard R. Pierce, Charles Ramsey, Fred A. Smith, Harold A. Tribolet, Leo McQueen, and Roscoe L. Graves. Not pictured are band members H. J. McKnight and Harold Gates.

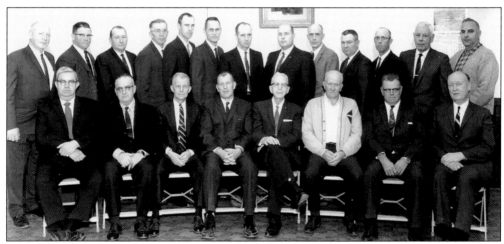

THE BRANCH COUNTY BOARD OF SUPERVISORS. The 16 townships were each represented by one supervisor; the city of Coldwater had four, and Bronson had two. Pictured in December 1968 are, from left to right, the following: (first row) city clerk Burdette Harris of Coldwater City; Leo Beery of Noble; Harold Sellers of Kinderhook; chairman Don Farwell of Butler; county clerk Earl Linn; George Hubbard of Union; Paul Brower of Bethel; and Mayor Marion L. Pillsbury of Coldwater City; (second row) Kenneth Netcher of Algansee; Leslie Onley of Girard; Carlyle Berlien of California; LaVerne Garman of Gilead; Merl Donbrock of Ovid; Robert Swanson of Coldwater City; Cleo Crandall of Batavia; treasurer William Grimes of Coldwater City; Merlin Young of Quincy; Berlyn Robbins of Sherwood; Earl Thrams of Matteson; Marc Semmelroth of Coldwater Township; and Max Foglesong of Bronson City.

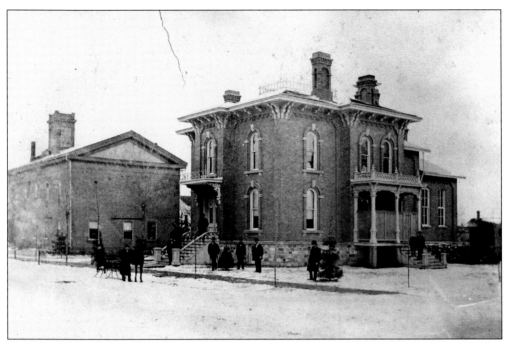

THE COURTHOUSE AND JAIL, C. 1880. Shown is the rear view of Branch County's first courthouse, built in 1848 in the Greek Revival style. In the foreground is the fifth county jail, built in 1875 in the Italianate style. The courthouse was replaced in 1888, and the jail was torn down in the early 1970s.

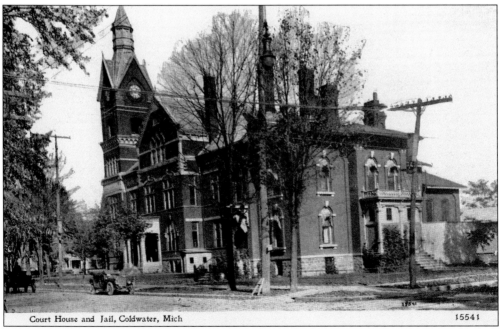

THE COURTHOUSE AND JAIL, 1912. The 1888 courthouse and the jail are shown in 1912 from almost the exact same angle as the photograph above. The courthouse suffered fire damage on December 5, 1972, and was later replaced.

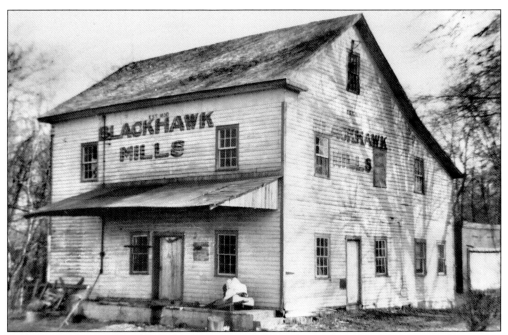

BLACKHAWK MILLS. Established in 1830, this mill was located south of the present-day airport on Benke Road. It is shown here in the 1960s just prior to its demolition. The mill had many owners in the 1930s and 1940s, including Frank L. Flack.

THE FIRST JAIL. Branch County's first jail was in this house, which was also the home of William McCarty, the first sheriff. Built in 1833, it was the oldest building in Coldwater when this photograph was taken in 1905.

One
THE NORTHEAST CORNER

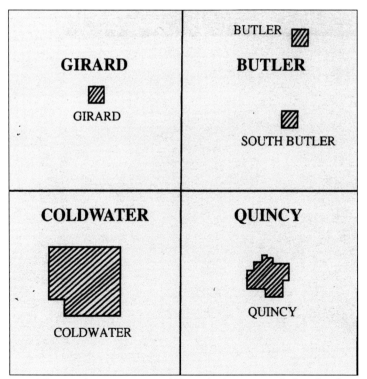

THE NORTHEAST. The northeast section of Branch County includes the four townships of Girard, Butler, Coldwater, and Quincy. The City of Coldwater was incorporated in 1861, and the Village of Quincy was established in 1858.

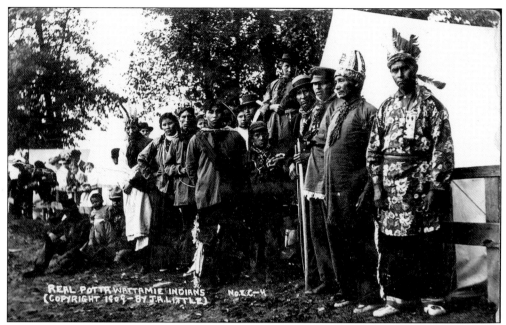

"REAL POTTAWATTAMIE INDIANS." This photo postcard, copyrighted in 1909 by J. A. Little, shows members of the Potawatomi Indian tribe. Jasper A. Little (1873–1956) resided in Battle Creek, Michigan. Although many of the Native Americans of this area were "removed" and relocated farther west in the 1840s, some stayed in this region and lived in and around the Athens, Michigan, area.

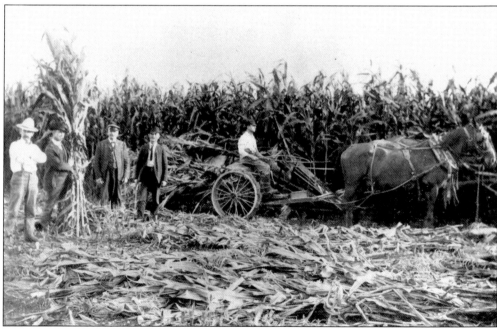

MILO D. CAMPBELL'S FARM, C. 1920. Shown is an ensilage cornfield, with heights ranging from 11 to 14 feet tall and producing 18 tons per acre.

Introduction

Branch County is rich in history, starting with the evidence of the "Mound Builders" whose ancestors may have been the Aztecs. The Potawatomi Indians were here as early as 1721. After the death of Chief Tecumseh in 1813, Chief Topinabee sold this area in 1821.

In 1829, Branch County was named in honor of John Branch, President Jackson's secretary of the navy. Branch County, located on the border of Indiana, was first attached to Lenawee County and later to St. Joseph County for judicial purposes. The first settler was Jabez Bronson, who arrived in 1828 from Connecticut. His relative Titus Bronson founded Kalamazoo at about the same time. The first county seat was at Masonville in 1830, but it was moved to Branch in 1831. Coldwater took the honor in 1842. The first courthouse was built in 1848. In 1888, it was replaced by a much larger courthouse, which served Branch County until it was destroyed in a disastrous fire in December 1972.

By the 1840s, the local Potawatomi Indians were being shipped to Kansas and farther west. Some tribe members stayed and settled in the Athens area of neighboring St. Joseph County. In 1850, trains stretched across Branch County, following the Sauk Trail westward from Detroit. Coldwater was incorporated as a village in 1837 and as a city in 1861. Bronson and Union City became villages in 1866, and Quincy was established as a village in 1858.

Branch County continued to grow after the Civil War, led by agriculture, the raising and selling of horses, the cigar industry, general business, and light industry. Branch County has over 100 lakes, and the vacation and tourism industry has strengthened the local economy.

This book details the history and growth of this important county. Small settlements, towns, villages, and cities are all documented with historic photographs. One-room schoolhouses, old churches, farms, and a way of life that is long forgotten are featured. Much has changed and much is gone, but, through these photographs, we can imagine bygone days, remember what was once here, and ponder the future of this wonderful county we call home.

ACKNOWLEDGMENTS

There are many people I would like to thank for putting up with me and my passion for collecting seemingly "unnecessary" items of our local history. Thanks to my parents, Calvin and Doris, and to my siblings, Cal and Gayle, for all of the love, laughs, and support. A very special thanks to my wife, Mary Kay (Hannon) Hazelbaker; I know living with a collector is sometimes challenging, and I appreciate your understanding and unwavering love. To my children, Gretchen and Audrey: Thanks for letting me grow up with you. And to my in-laws, Jim and Mary Ann Hannon, thanks for all the help and support.

I would also like to thank several people for helping me collect Branch County postcards, photographs, and memorabilia. I will never forget receiving the 1906 edition of *History of Branch County* from neighbor Kay Shattuck and how it sparked my interest at an early age. To Chuck Woodward, who was always helpful at the Holbrook Heritage Room at the Coldwater Public Library; I miss you. Thanks to the Branch County Historical Society, housed in the remarkable Wing House Museum, for always keeping me on my toes.

A photograph records and freezes a moment in time. It is evidence of a past event, of what was and is no more. I sincerely hope you enjoy this book. Please appreciate the past and the wonderful things in it.

RANDALL HAZELBAKER. The author serves as a local historian. (Courtesy SPI Photo.)

Contents

Acknowledgments 6

Introduction 7

1. The Northeast Corner 9

2. The Southeast Corner 61

3. The Southwest Corner 83

4. The Northwest Corner 105

Copyright © 2005 by Randall Hazelbaker
ISBN 978-0-7385-3964-53

Published by Arcadia Publishing
Charleston, South Carolina

Printed in the United States of America

Library of Congress Catalog Card Number: 2005930281

For all general information contact Arcadia Publishing at:
Telephone 843-853-2070
Fax 843-853-0044
E-mail sales@arcadiapublishing.com
For customer service and orders:
Toll-Free 1-888-313-2665

Visit us on the Internet at www.arcadiapublishing.com

For my daughters, Gretchen and Audrey. "Long ago, and far away, there lived a man named Peter Hasselbacker…"

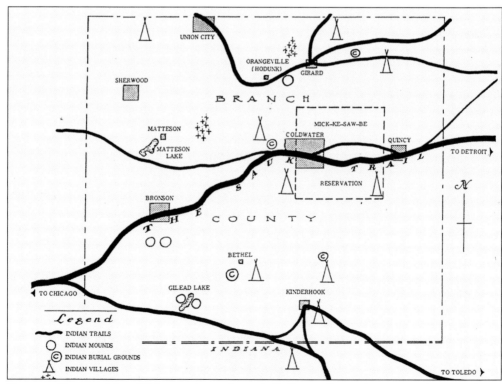

BRANCH COUNTY MAP. This map shows the early Indian trails, settlements, and reservations.

Randall Hazelbaker